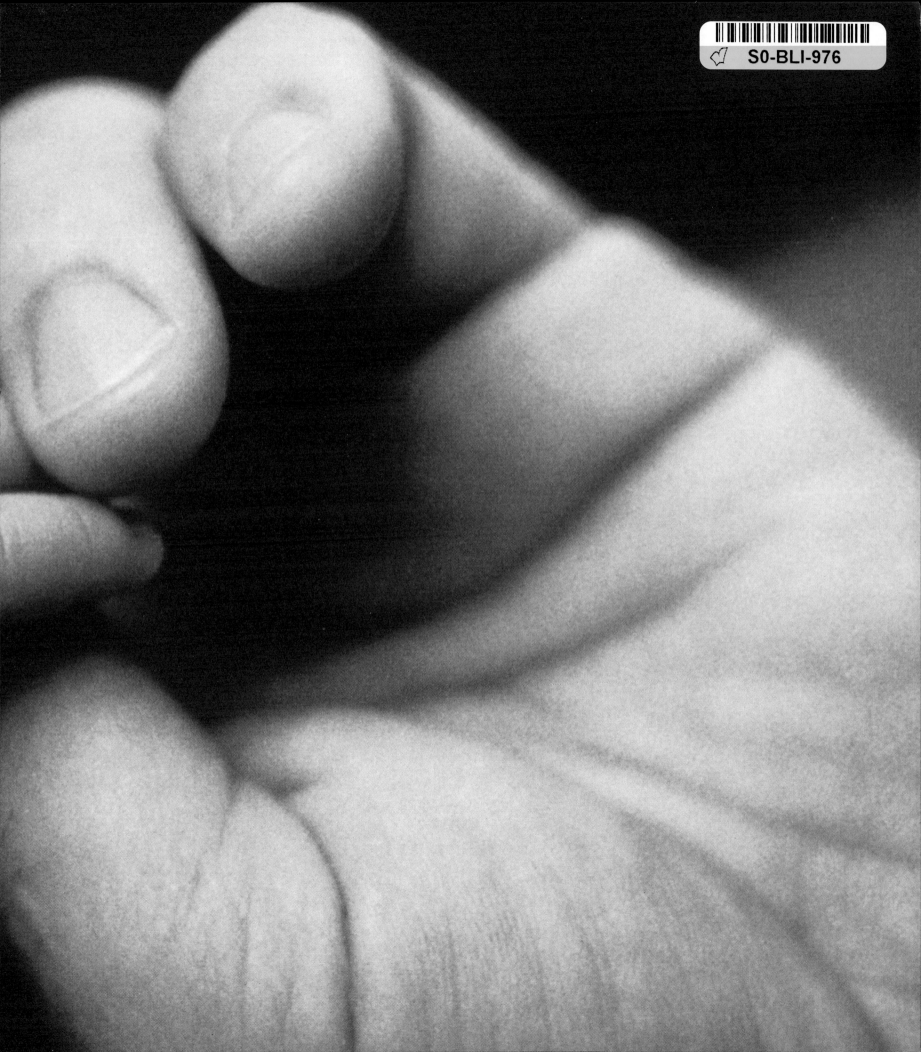

DADS LOVE BABIES

A CELEBRATION IN WORDS AND PICTURES

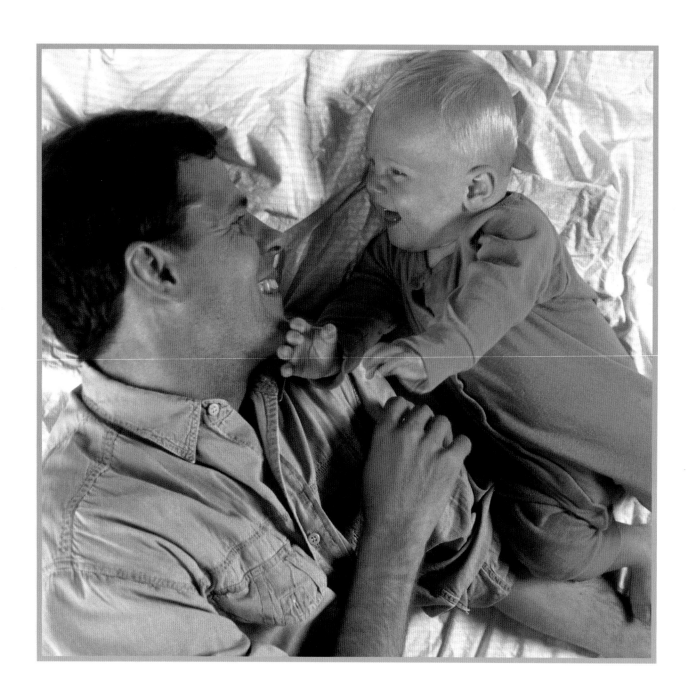

DADS LOVE BABIES

A CELEBRATION IN WORDS AND PICTURES

WHITNEY MCKNIGHT

SMITHMARK

This edition published in 1999 by SMITHMARK Publishers, a division of U.S. Media Holdings, Inc.,
115 West 18th Street, New York, NY 10011.

SMITHMARK books are available for bulk purchases for sales promotion and premium use.
For details write or call the manager of special sales, SMITHMARK Publishers,
a division of U.S. Media Holdings, Inc., 115 West 18th Street, New York, NY 10011; 212–519–1300.

Designed by Jessica Shatan

ISBN: 0-7651-1065-2

Printed in Hong Kong

10 9 8 7 6 5 4 3 2 1

Library of Congress Cataloging-in-Publication Data

McKnight, Whitney.
 Dads love babies : a photographic album / Whitney McKnight.
 p. cm.
 ISBN 0-7651-1065-2 (alk. paper)
 1. Father and infant--Pictorial works. I. Title.
HQ755.84.M35 1999
306.874'2--dc21
 98-46394
 CIP

Contents

Acknowledgments

I would like to thank all the daddies for taking time away from their busy baby schedules to answer my questions so thoughtfully and enthusiastically. May you all live long and happy lives enjoying the company of your children and your children's children. And a special thanks to BKC and DLG—you helped make it all possible.

Introduction

No going back. A ticket to ride, never to step off. Fatherhood has indelible impact. Once you are a father, you are never not a father. How scary! How thrilling! How wonderful!

In addition to being irreversible, fatherhood is multidimensional. In *A Man Called Daddy*, Hugh O'Neill writes: "Becoming a father changes everything. And I do mean everything: the way you work, sleep, drive, eat, dress, think. It even changes what you sing. Fatherhood changes your posture, your sex life, your hairstyle, your feelings about money, about politics, God, about your past, and about the planet's future. Children change the ground you walk on."

On these pages, with candor and humor, fathers share portions of their own journey into fatherhood: their fears, their joys, their hopes and dreams. All the reasons why dads love babies.

DADS LOVE BABIES

A CELEBRATION IN WORDS AND PICTURES

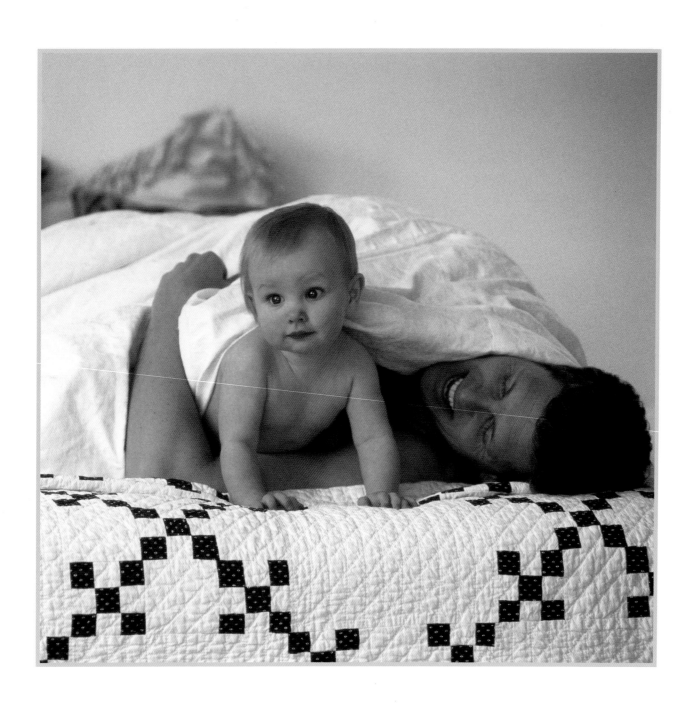

1

You're Going to Be a Father

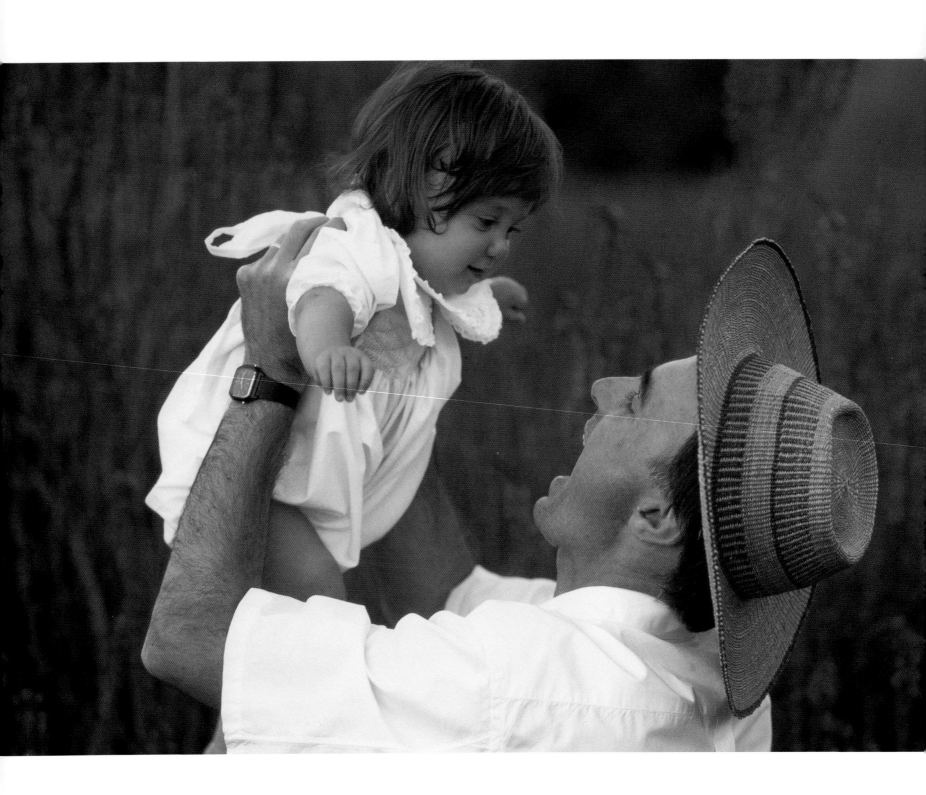

MEET THE DADDIES

The fathers who share their experiences in this book all come with different perspectives—some are from large families, some are only children. Each has a unique view on the roles fathers play in their children's lives, and about the way their children have transformed them.

John Z., thirty-eight, is from a large family, the second of seven children. He and his wife have two children, a son, now two years old, and a daughter, two weeks. They had hoped their second child was a daughter, and now that she has been born, they do not plan on having any more children. John works part-time from his home as a science writer and editor. He is also the primary caregiver in the family, as his wife works full-time as a payroll supervisor at a local library.

John M., thirty-one, also comes from a large family. He is the second youngest of seven. He and his wife have two children, a son, now three, and a daughter, one. They plan to have one more child. John works full-time at a bank as a commercial real estate appraiser, and has his own home-based part-time appraisal business. John's wife stays at home with the children, although John's office is five minutes from the house so he sees the family every day for an hour at lunch.

Mark, forty-four, is the youngest of five. He and his wife have a one-month-old son and plan to have two or three more kids over the course

Left: "I'll learn to fly later. Can I play with your hat now?" A little girl checks out her papa's lovely chapeau on a country afternoon.

3

of four more years. Mark is a bioengineer-turned-opera singer who now owns his own computer consulting company while still singing part-time. Mark's wife, before getting pregnant, had just begun the certification process for getting her contractor's license and plans to eventually complete the process. Meanwhile, both parents are home with their son around the clock, as Mark's freelance schedule allows him enormous freedom to be with his family.

Harvey, forty-three, is a financial analyst, and an only child. He and his wife have an eight-month-old son. They are not sure if they plan on having any more children: Harvey's wife fears she may be too old to endure a second pregnancy with no complications to herself or to the child. Since both Harvey and his wife work full-time (she is also a financial analyst), they have a full-time nanny to help them with child care.

Michael, fifty-three, is an only child. He and his wife have one six-month-old son, who was conceived using in vitro fertilization. Using the remaining eggs harvested from the egg donor of their first child, they plan on having one more pregnancy, although expect that it may very well mean they end up with twins, since IVF often results in multiple births. Michael is a partner in a graphic design and typesetting company.

Rodd, twenty-eight, is the youngest of three. He and his wife have a son, aged eight months. They are undecided on the size they would ultimately like their family to be, since Rodd's wife comes from a large family and is considering recreating the same. She is a freelance radio news

Right: Before a baby can manage his first steps, he needs to find his balance. This dad offers a stable lap to his joyful son.

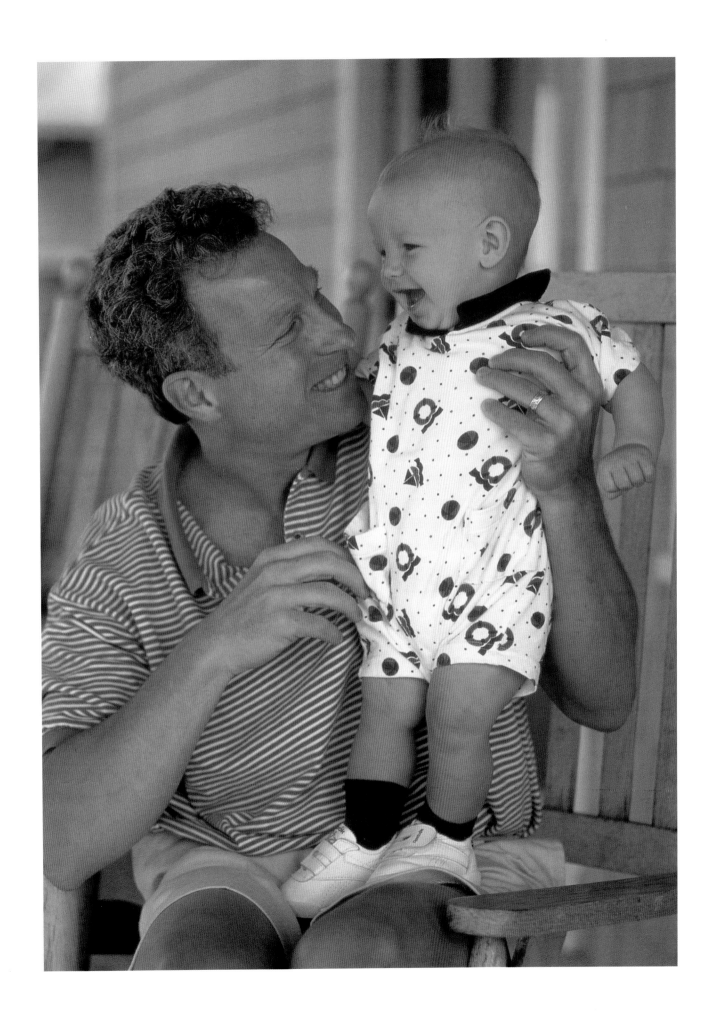

reporter and producer currently giving full-time care to their son. Rodd is a motion picture advertising producer.

David, forty, is also the youngest of three. He and his wife have a two-year-old-son and do not plan on having any more children. David is an opera singer-turned-Wall Street human resources manager. His wife is a part-time freelance writer and editor who works from home, balancing career with homemaking. While David's wife is the primary caregiver, they also utilize a part-time sitter, a backup child care facility provided by David's company, and an occasional swap of baby-sitting services with other mothers of toddlers in the neighborhood.

Right: Dads often hope that their new babies will have smiles that take after their own. The anticipation of who the little one might turn out to be leaves plenty of room for speculation.

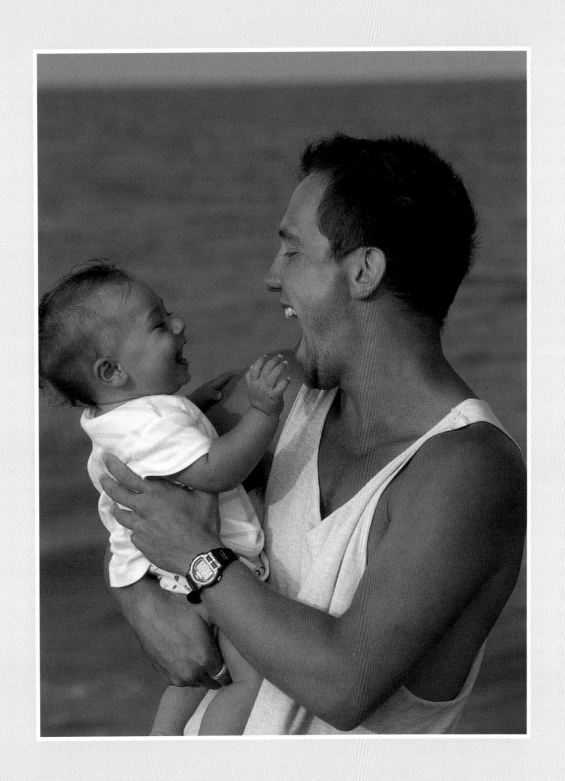

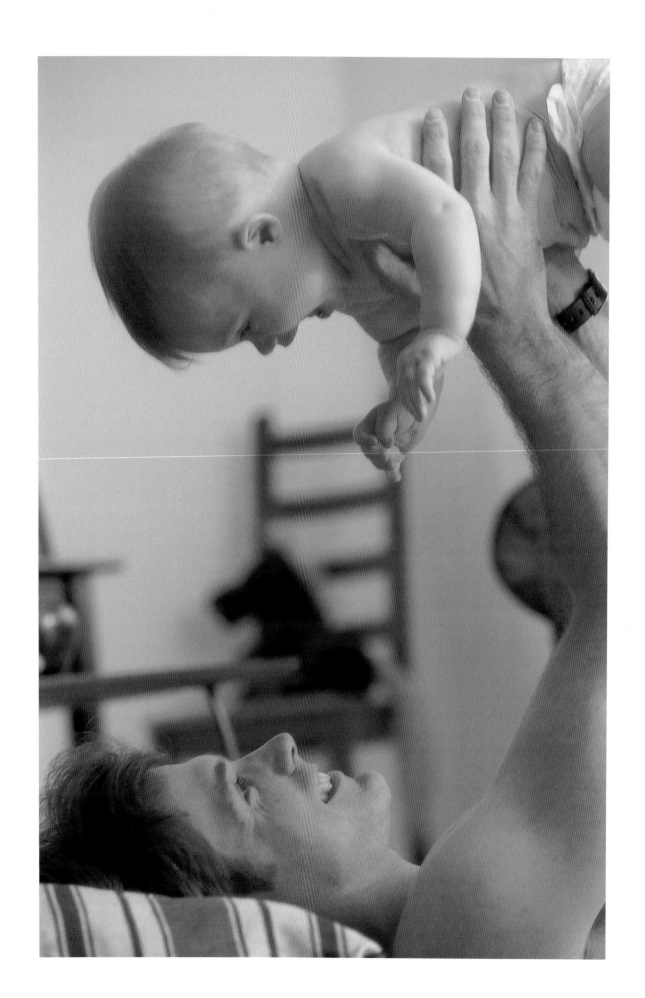

THE ANNOUNCEMENT THAT
CHANGES YOUR LIFE FOREVER

"Honey, I have something to tell you . . ." A small statement with such large implications. Nothing will ever be the same again once these words are spoken: "You're going to be a father." Whether a man is hearing these words for the first time or the fourth, they immediately conjure delightful fantasies as well as bouts of intense self-examination. Your heart races as you feel the anticipation of cradling a newborn and smelling that scent only a newborn has; you feel the poignancy of knowing that soon a child will cry out to you in the night, afraid of the dark; you remember the angst of adolescence as you recount the humiliation and shame of not being chosen to play on a team. Your heart leaps to imagine the thrill of seeing your child's eyes shine with pride when he has finally mastered a two-wheeled bike, and dances as you envision the smile of delight upon your daughter's face when she is bowled over by the family dog and then licked mercilessly across the cheek. As John Z. puts it: "It's like winning the lottery. You feel something like shock, and you ask yourself, Is this really happening to me? And the answer is, yeah!"

Left: A baby has total trust in his or her father. That's what makes flying so fearless and so easy.

THE NEWS

David says: "We both had known pretty much the exact time when we conceived; it was strange, but we did. As for the official pronouncement, I'm actually the one who told my wife. She had given her doctor permission to leave any information either with me or on our voice mail. The evening when we thought that the doctor would have the blood test results, the lab results were late. We were impatient to know, however, so my wife walked down to the local drugstore to buy a home test kit.

"While she was gone, her doctor called and said the results has just arrived, albeit later than usual. We didn't need the home test kit anymore, and besides, I was excited, so I walked down to the drugstore to meet my wife. She was already heading home. I told her the doctor had called and that she should take the test back. I didn't want to tell her what the results were exactly, standing there in the middle of the street, in front of a gas station, no less, but she insisted. Actually, it was pretty neat, because it was a clear November night and the full moon was right above us. And, as my wife later pointed out to me, it had been three years prior to that, under a full moon in November, when I had proposed to her.

"Anyway, we returned the pregnancy test kit and went home and immediately called everyone we could think of to tell them the news. There'd have been no point in trying to keep it secret, since my wife can't do that sort of thing well."

Harvey and his wife work for the same company, so when her doctor called with the news, she rushed into his office. He was already in a

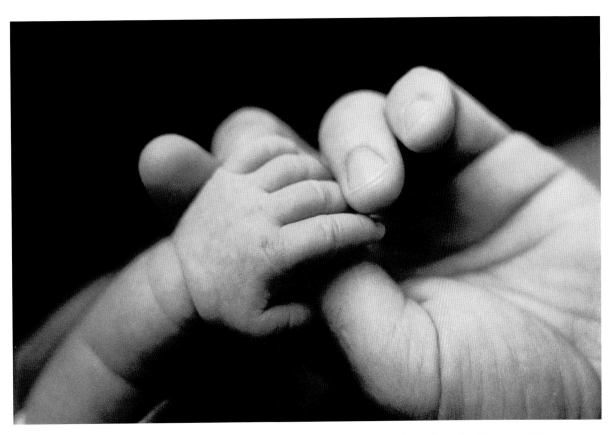

Above: "You are so small, so delicate, and I am so big and awkward. How will I ever manage?" Yet a new father finds a way and the bond begins.

meeting with someone, so, practically busting with the news, she waited until they were alone. Harvey recalls that it was late in the afternoon when she told him and that he was glad for it: "I couldn't really concentrate after that so we left early and went to dinner to celebrate—without alcohol," he laughs. "Plus, it was Valentine's Day so that made it extra-romantic. It was a real fairy-tale day for us."

Ask Michael how he discovered he was going to be a father, and he'll laugh. There was no way for him not to know, since he and his wife

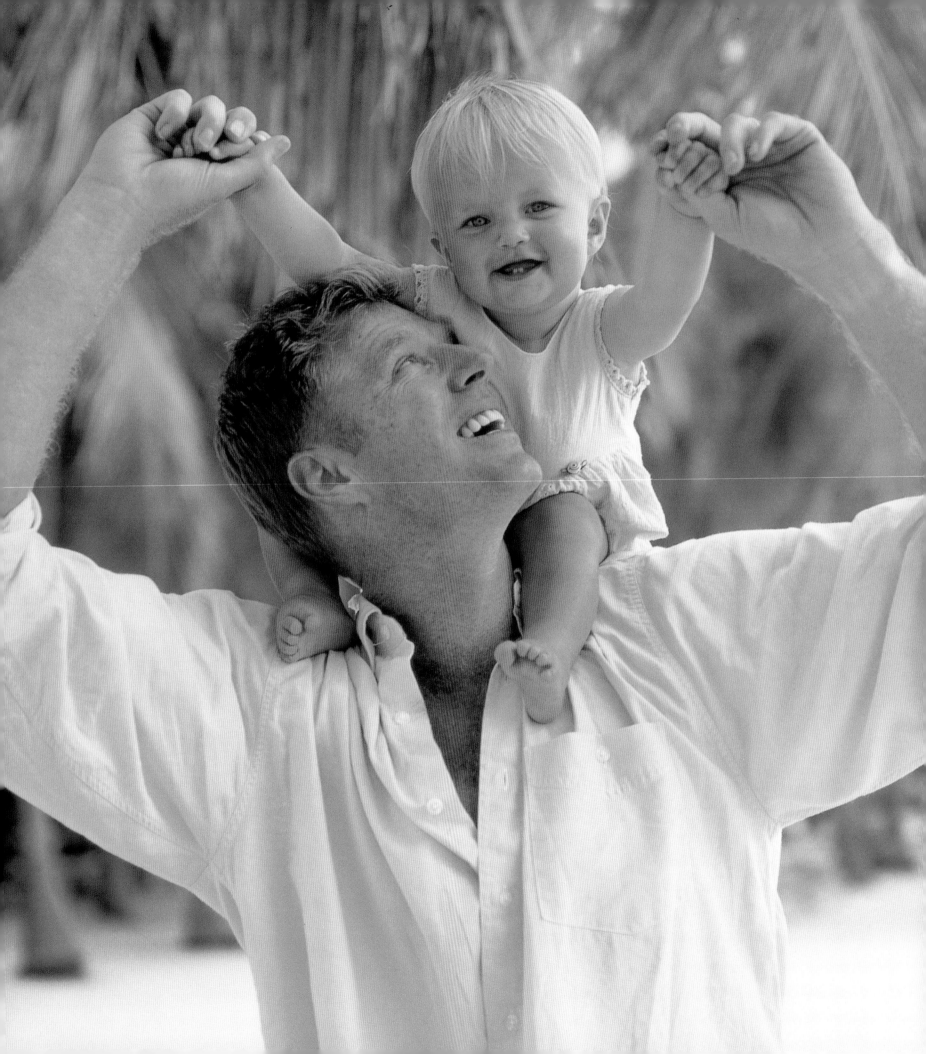

helped choose the embryos they hoped would result in their first child. After reviewing dozens of potential egg donor files supplied to them from agencies in New York City, Michael and his wife were disappointed with the results. Much to their frustration, various laws and guidelines in New York prohibit parents from getting information, such as an egg donor's family mental health history. They decided to do their own search, focusing their efforts in California, where there is less regulation of information in such cases. Within a couple of months, using an essay-style application form, they chose a thirty-one-year-old woman whose characteristics—everything from physical attributes to sense of humor—matched as closely as possible those of Michael's wife.

Jubilant, they flew to California once their chosen donor had been on the egg stimulation therapy long enough to produce eggs for harvest. Michael says that while many parents choose not to meet the egg donor, they were very interested in getting to know her and even met her mother. For successful in vitro fertilization, once the eggs are surgically retrieved, they must be fertilized within two days. Michael recounts how he and his wife, following the guidance of the lab technician, chose the embryo that seemed healthiest and then had it implanted.

As if this weren't dramatic enough, after all the careful planning of this event, Michael's wife developed a severe rash from poison ivy, contracted before they left for California but not evident until they had arrived. They felt too much was at stake not to go through with the process, but

Left: "A baby can teach the clumsiest of men infinite gentleness."
—Marion Garretty

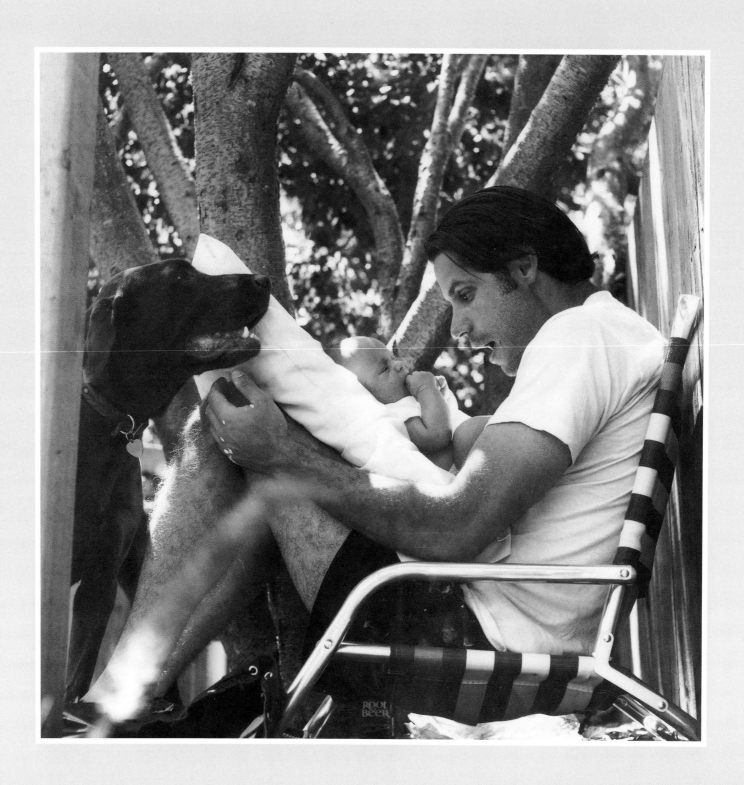

they did worry that her immune system might be so stimulated by the rash that it would reject the embryo and expunge it from the womb before it had a chance to firmly implant itself. In the end, all was fine, as was confirmed two weeks later by results from a pregnancy test.

Things were a little more straightforward for Mark and his wife. He says: "We learned from a home pregnancy kit. She had been sick all day, and although I am convinced that it wasn't morning sickness at that point, we went ahead and got the test anyway. It proved immediately positive. Actually, I told her, as I was the one who read the results."

Left: The breeze says hello, and the trees say hello, and Champ says hello. We're all so glad you're here!

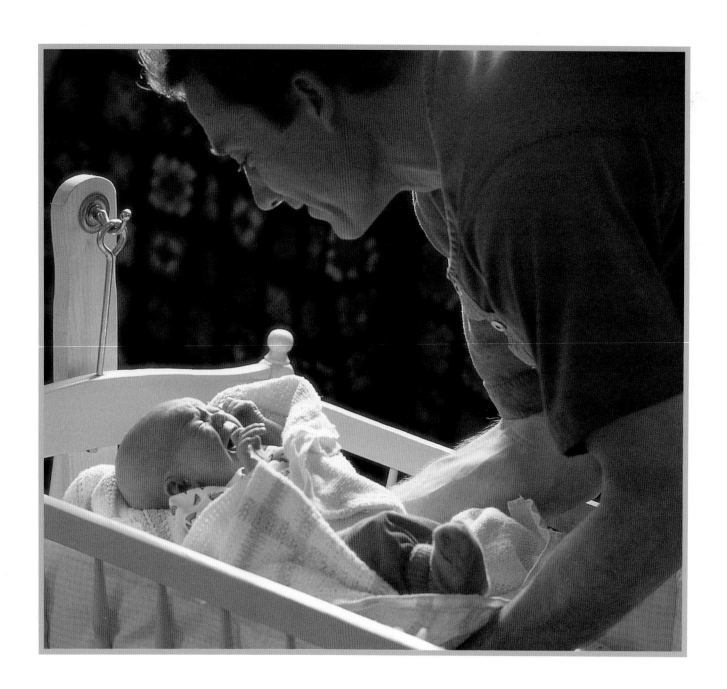

2

FEARS AND ANXIETIES

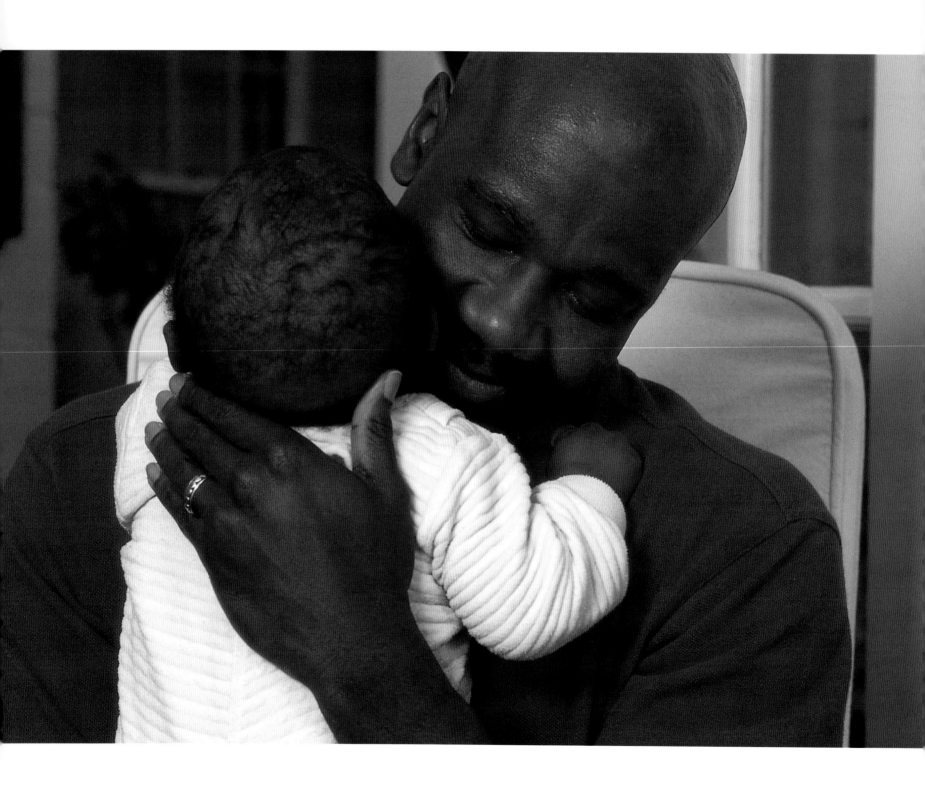

A dad-to-be's mind races: "What if there's a satellite snafu so my cell phone doesn't work when my wife calls to tell me she's in labor and I'm stuck in traffic anyway? Or, what if the so-called triple blood test results show a higher than average chance our baby will have chromosomal abnormalities? What if something happens to my wife?"

The list of potential crises seems endless. "Can I cope?" a man wonders. And perhaps other thoughts fill his mind, ones that he might or might not share—thoughts like: "Am I really ready for this? What if I can't stand the pressure during the delivery, the time my wife will need me the most? And even worse, what if I am a horrible father altogether?"

A man may not be responsible for the actual physical development of the child still in utero, but his thoughts will surely turn to what he feels are his responsibilities nonetheless. Anxiety levels may skyrocket as situations he used to take for granted suddenly become gripping and fraught with fear. In his mind, a job considered steady for years suddenly seems tenuous; a housing situation once comfortable—or at least bearable—suddenly becomes untenable. A paycheck that once seemed sufficient, even if it was not all it was desired to be, immediately seems paltry. Some men may even go so far as to feel anger at the impending change in their lives. Some might become depressed. Still others might seem permanently drugged with glee, either because of an unswerving conviction that all will be fine, or because they are too frightened to consider the other possibilities. Whatever the reaction, it's all normal, it's all universal.

Left: The gentle rhythm of a newborn's breath upon its father's face is like a meditation:
"You give me hope."

According to Rodd, having an offbeat attitude made it easier for him to cope. Chief among his fears were "death and deformity." But, referring to himself and his wife—his partner of ten years—Rodd says, "We faced our fears the way we face most things: with tasteless humor. We pretended to be terrified when the [baby's in-utero] hiccups stopped and made jokes about our imaginary child with 'special needs.' We even kept it up when a

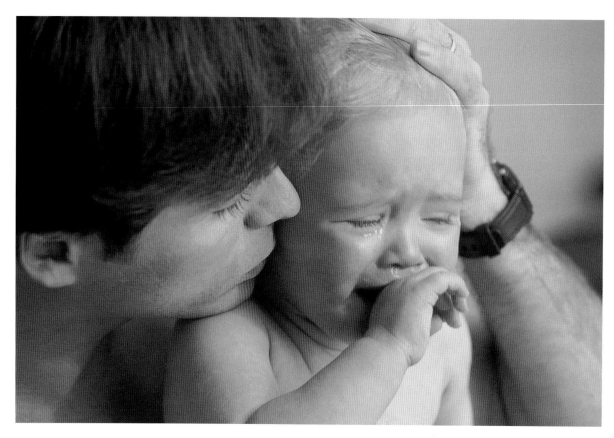

Above: A dad's heart breaks when his little one is in pain. Right: Babies seem to know that dads make the best playmates. But who knows whether their dads might be having even more fun than they are?

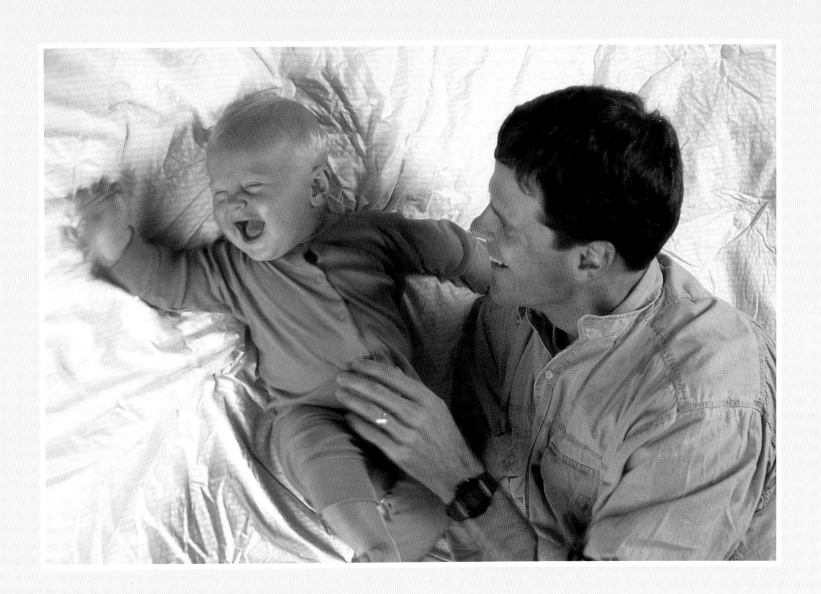

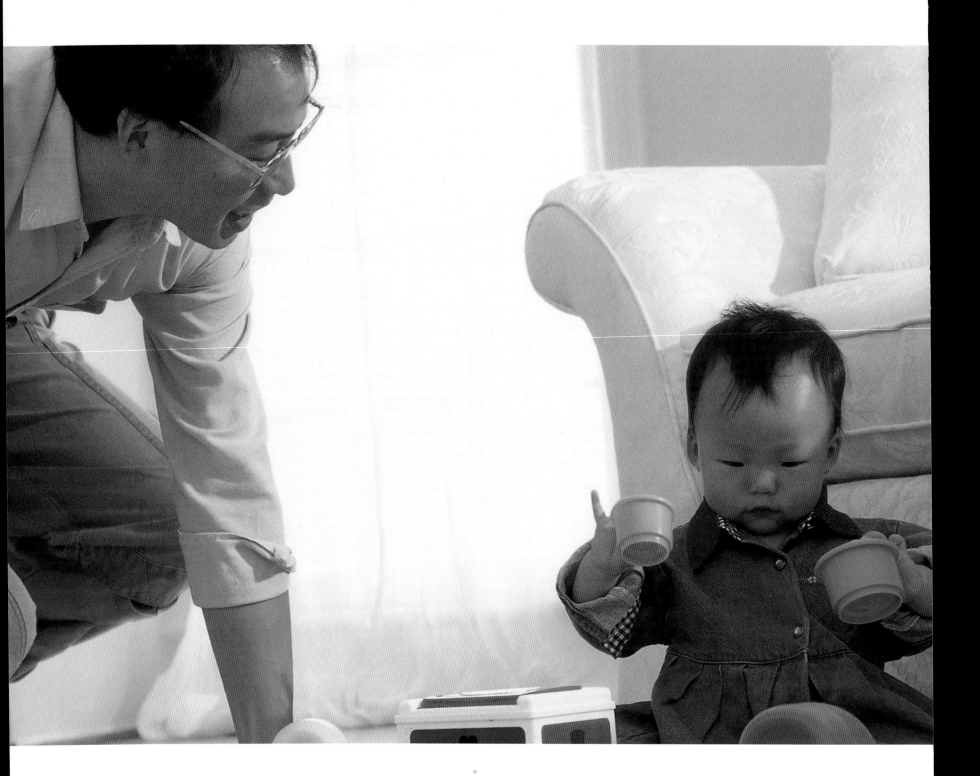

blood test showed a stronger than average chance of Down's syndrome (everyone's always seems to). It may have been easier to have a sense of humor because we didn't have a name picked out and didn't know the sex of our child. But we also knew that any serious problem would have to be dealt with seriously if it presented itself. Until then, it only made sense to have fun with everything."

Whether they laughed about it or not, all the fathers who shared their experiences for this book cited fears of something traumatic happening to both wife and baby, either before the baby was born or after. In Harvey's case, his fears intensified once he was actually holding his son in his arms: he was terrified of hurting such a small being.

Says Harvey, "I kept thinking, 'He's so delicate and fragile. Will I drop him?' I was also afraid of being alone with him, in case something happened and I didn't know what to do." Compounding this fear, confides Harvey, was a fear that he wouldn't be any good at nurturing his child. But these fears quickly evaporated and Harvey now reports that his son is "so much fun and it's so gratifying to be involved in his development."

Another fear Harvey admits having was that he would never have enough time to finish all that needed attention during the day. But, as every father interviewed said, "You just reorganize your priorities."

David confides: "I was very afraid of being a father, period. I really doubted that I could do a decent job. That lasted for about the first six months. I also worried about the baby some, especially as we had a false

Left: Tea parties—complete with proper pinky placement—have always been a favorite activity of dads and babies.

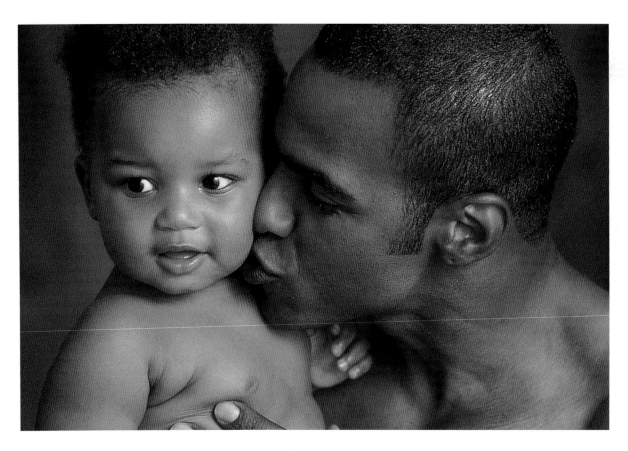

Above: Baby kisses are the sweetest, even when babies find some things more interesting than a smooch from Papa. Right: "He's cute, Dad. But he's not as soft and cuddly as I am!" What could soften a dad's heart more than his baby girl and her puppy?

positive show up on the triple blood test, indicating a higher than normal chance of genetic defect. We elected to have the amnio, and as it turned out the test was inaccurate and everything was all right. Overall, I was actually more afraid for my wife's health during the birth than for the baby's. I think that was because I didn't know the baby as a person yet."

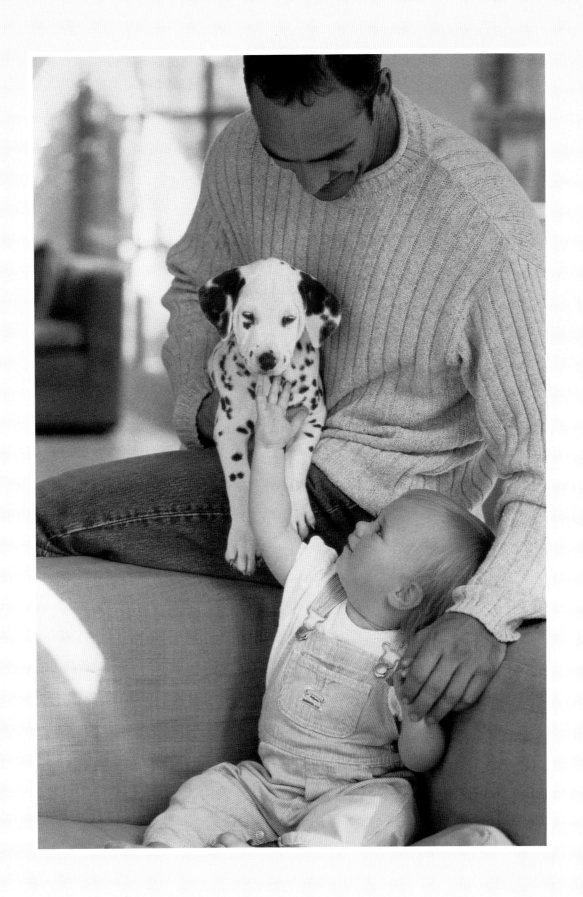

Michael relates that once his wife was pregnant, they had the same sorts of anxieties any parents-to-be might have, regardless of the method used to create the baby. In fact, they had practically no worries about their child being deformed, since, while his wife was thirty-nine at the time of conception, the egg was from a woman roughly ten years younger, and, so the theory goes, the egg was healthier. What they were concerned with was bringing their child to full term, since during the pregnancy his wife developed gestational diabetes. Using ultrasound, they also discovered that the baby was placenta previa and would have to be delivered using cesarean section.

John Z. said his fears were actually more pronounced the second time around. He was pretty confident each time that his wife would be okay and that the delivery would be fine. What he did worry about with their first child was whether or not they had enough space in their city apartment and how he would successfully manage his business obligations while also being the primary caregiver. He was just beginning to find a rhythm when his wife got pregnant a second time. Reflecting upon how, almost from birth, his son had been "turbo-child," he panicked that he would not be able to meet the demands of caring for two children. He has a day-care center lined up for backup duty; meanwhile, his wife is on maternity leave from her job, and together they are managing.

Right: At first, dads fear they will roll over and crush their tiny newborn as they drift off together. But the endless hours of feeding and rocking eventually force a dad to trust they'll both sleep quite well.

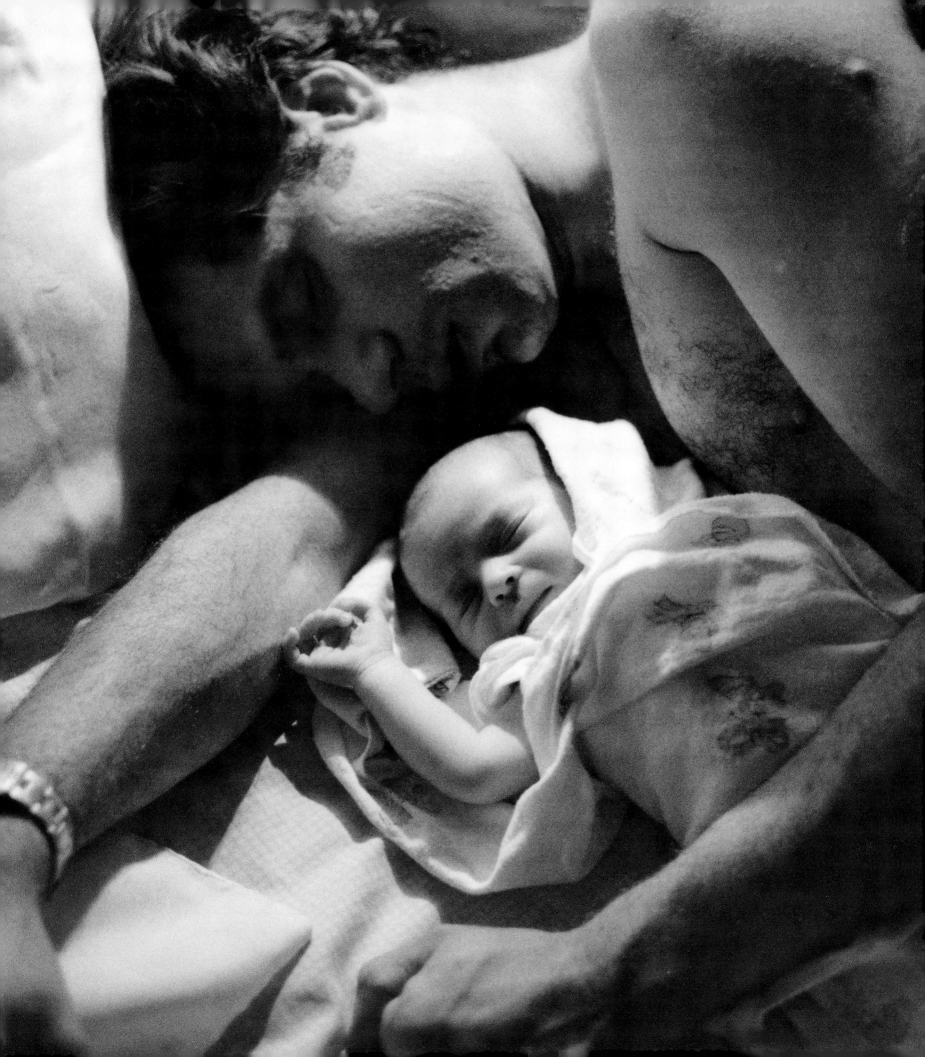

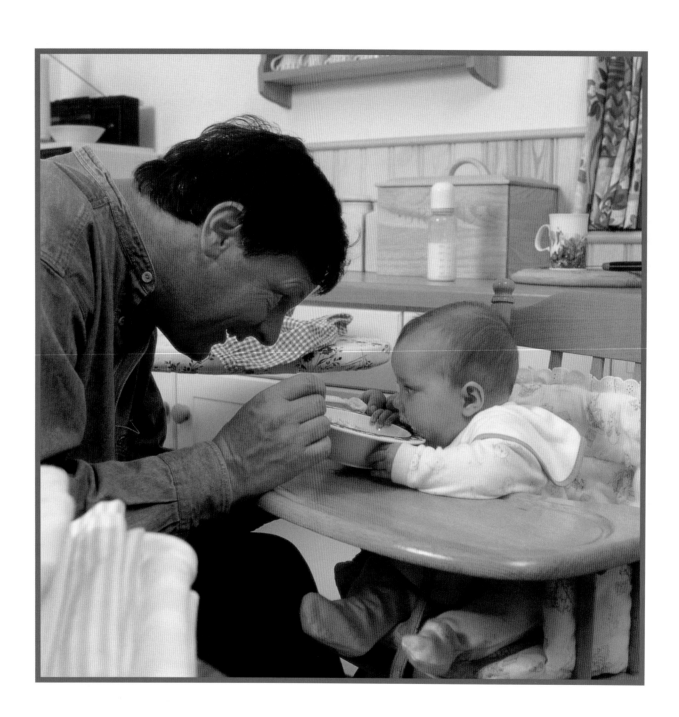

3

Dads Prepare for Their New Role

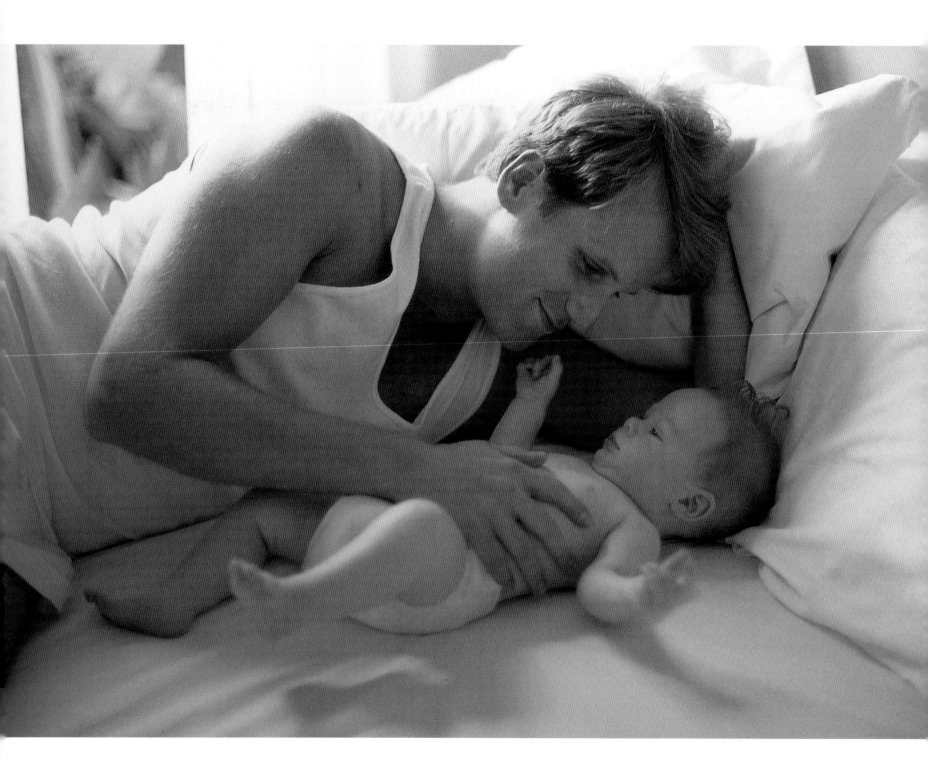

WHO AM I?

Besides questioning their abilities to cope with what's soon to come, dads inevitably find themselves wondering who they are and how fatherhood will reflect that reality back to themselves and to the world at large. Along with gathering the fortitude to face their new role as a father, fathers-to-be are bound to conduct an intensive self-inventory both before and after the arrival of their children. A man might have misgivings about whether or not God exists, and in what form, or reflect upon the nature of his relationship with his own father. It may even be a time when a man wonders if he has grown up enough to really consider himself the genuine article: "Should a 'real' dad actually own a heavy metal CD collection?" a man might ask himself, only to learn that once his newborn has arrived, he has precious little time to listen to any music at all.

Rodd looks at it all philosophically: "A friend of mine believes that people are driven by their egos to have children, that children are a grand monument to themselves. As bad as that sounds, I can't completely disagree. But I do think people have children to enrich their own lives and to take themselves to another level. Having a child has been sort of a challenge to myself to work harder at life and to contemplate the values I hold that are worth passing on to someone else."

Left: When a new baby arrives, a dad feels like he could just stare for hours at his little one, wondering how such a miracle could ever have come to bless his life so.

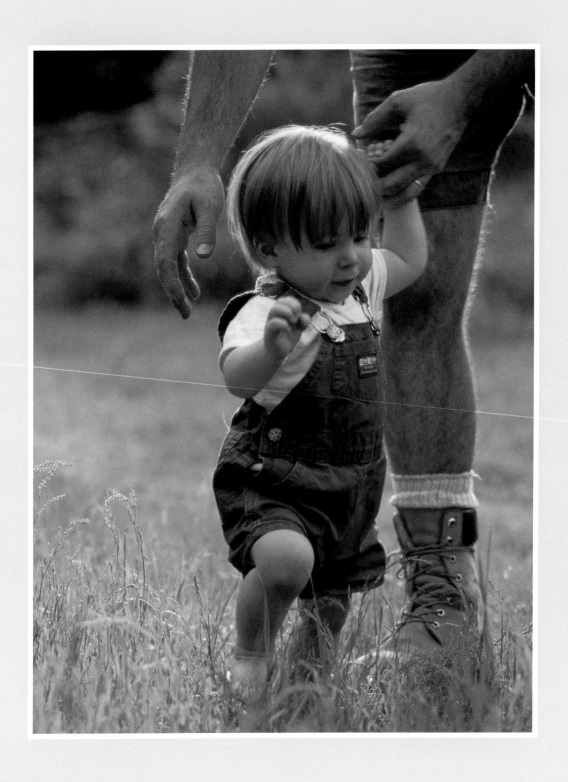

Considering his own childhood, Rodd goes on to say, "I was the same age as my father when I had my son. So it's easy to imagine where he was in his life. I don't think my perception of my dad has changed, but I'm glad to have been able to reward him for his great parenting with a grandson. Now he gets to enjoy once again the thrill of having a baby around without any of the day-to-day duties."

John M. concludes that he could never have even begun to understand the amount of work his parents had on their hands with their seven children. "It made me appreciate my parents all the more, and I'm a lot closer to my own father," he says.

John Z. has the opposite reaction: "Being a parent has made me realize how little my father actually did to parent us when I was a kid. I have flashbacks now all the time of how self-absorbed my dad was. I don't feel angry about it, but he really was wrapped up in his own world, studying for his medical boards, and eventually as a practicing surgeon." However, John Z. says any hardship placed upon his mother for having to handle so many children primarily on her own was made less severe by the fact that within a five-mile radius were numerous extended family members. "Kids' birthdays in our family weren't just little parties, they were fiestas, what with all the cousins who would show up."

It has been the birth of his own son that John Z. feels has helped him further a relationship with his father, which he never could have dreamed of having as a kid before his father's retirement. "I've spent

Left: A father guides his son through a barefoot journey, the first among many journeys they will share.

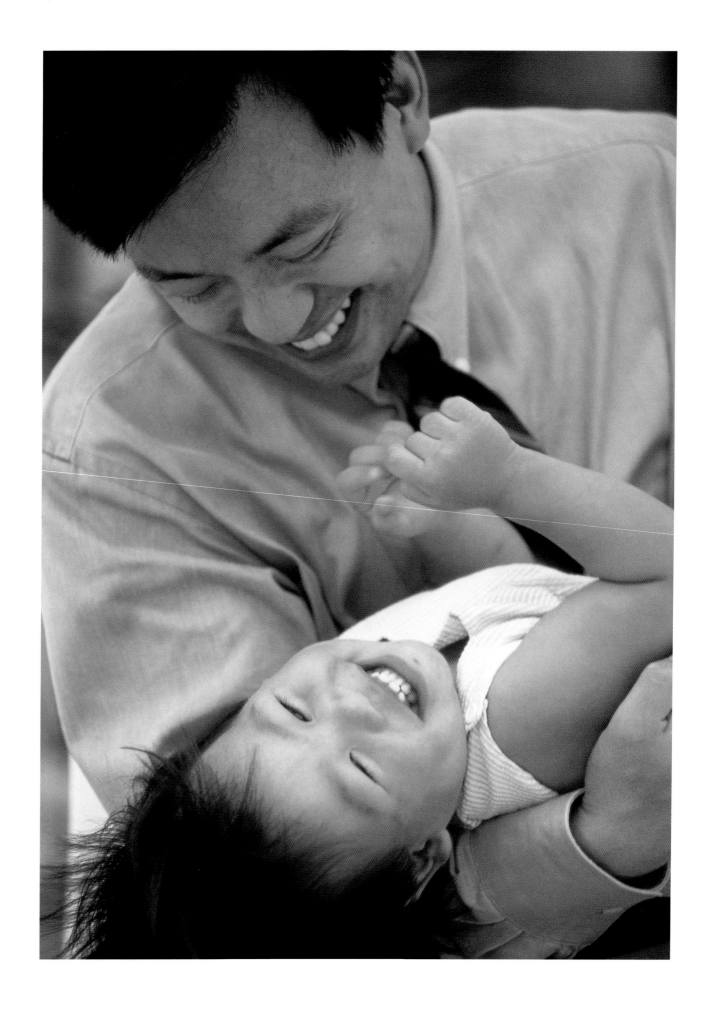

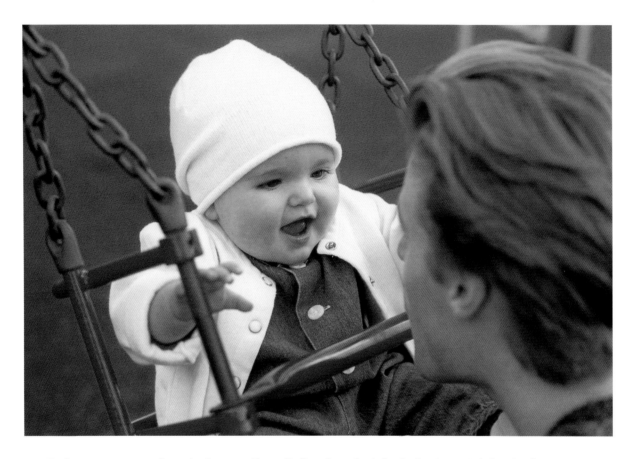

Left: No matter what the dress code, a dad takes the job of playing with his little one very seriously. Above: Places like playgrounds and jungle gyms are among a new dad's and his child's favorite hangouts.

more time with my father in the last ten years than I ever did when I was a kid. It's nice, and like I said, I'm not angry about what happened when I was a kid, but I do have to say that I resent it when my dad gives me parenting advice, since he wasn't around much himself. How would he know? But I'm giving him a chance to make it up to his grandson, since he's mellowed so much."

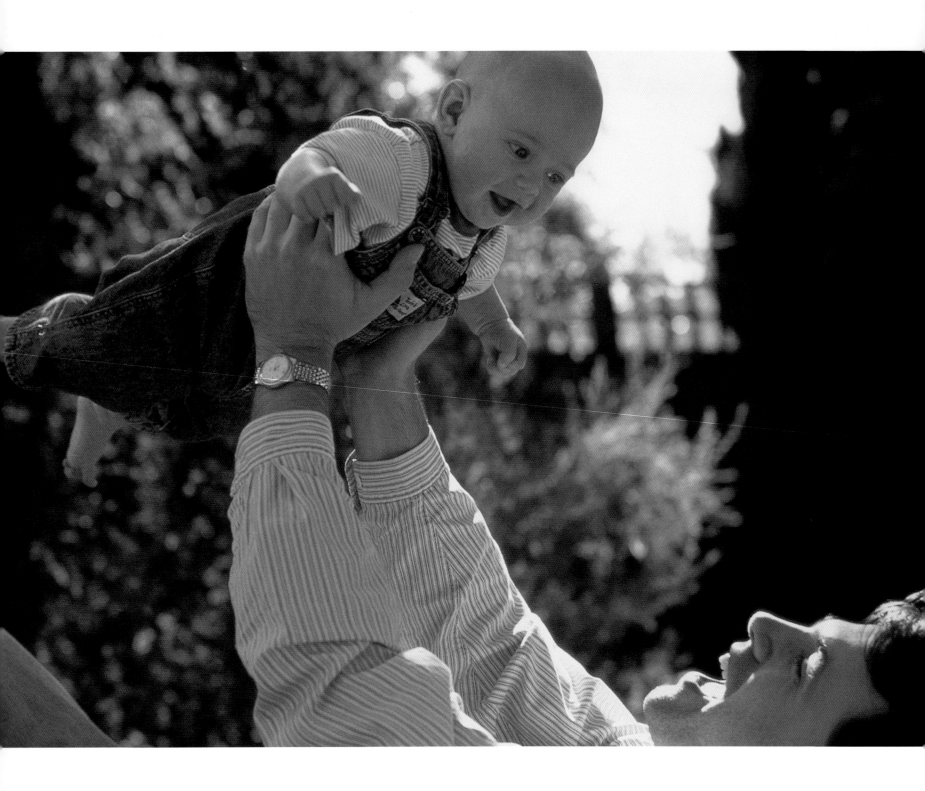

For Mark, whose mother's life was tragically altered by the death of her first husband in combat during World War II, his relationship with his two older half-brothers was more avuncular, since they were eighteen and sixteen years his senior. As for Mark's relationship with his father, he says: "Being a father makes you think about how [your own father] treated you. There's a whole book on that subject, I'm sure, but suffice it to say my father was a kind and gentle man. He was also quite outnumbered and overpowered by two very strong women in the family, my mother and grandmother, [who] lived with us and actually provided the childcare, as my mother worked. He didn't have much to say in the baby-bringing-up department, and worked [at his job] very hard. He seemed old to me, and wasn't particularly athletic, although he enjoyed being a spectator. Interestingly, I'm a couple of years older than my father was when I was born, so I'm very aware of wanting to be in good physical shape so I can participate with my son in physical activities." Mark also considers that having a son has reinvigorated his interest in a career that, until his son's arrival, he had been questioning the merits of: "It's made me want to be a singer again. Somehow, I want [my son] to know Singer Dad, as well as (if necessary) the Logical Engineer Dad."

Michael's father died before he was born and his mother never remarried. He says that not having had a father as a child hasn't greatly impacted his own fatherhood other than to instill in him a strong desire to really know his son, since he didn't know his father.

Left: You're a bird, you're a plane, you're the apple of my eye! When you smile like that at me, it's my heart that flies!

For his part, Harvey reflects upon how his fatherhood ties him to his ancestry and his family traditions. "I'm Jewish," he says. "And the Hebraic tradition is to name every child after someone in the family who is deceased as a way to honor and respect them. So my wife and I spent a lot of time thinking about that while we were trying to decide upon a name. We were adamant about keeping the element of surprise and we made it very clear to the lab guy not to tell us the sex of our baby. Not knowing the baby's sex ahead of time limited our name choices a little bit."

For David, taking on the role of father caused him to take stock of what in his life was still vested in the past. "It made me get serious about finally discarding the emotional garbage I'd accumulated in my life, tossing out what just didn't make sense to hang on to anymore and to really live 'out loud' the things which are."

Right: "A father is more than a hundred schoolmasters." — George Herbert

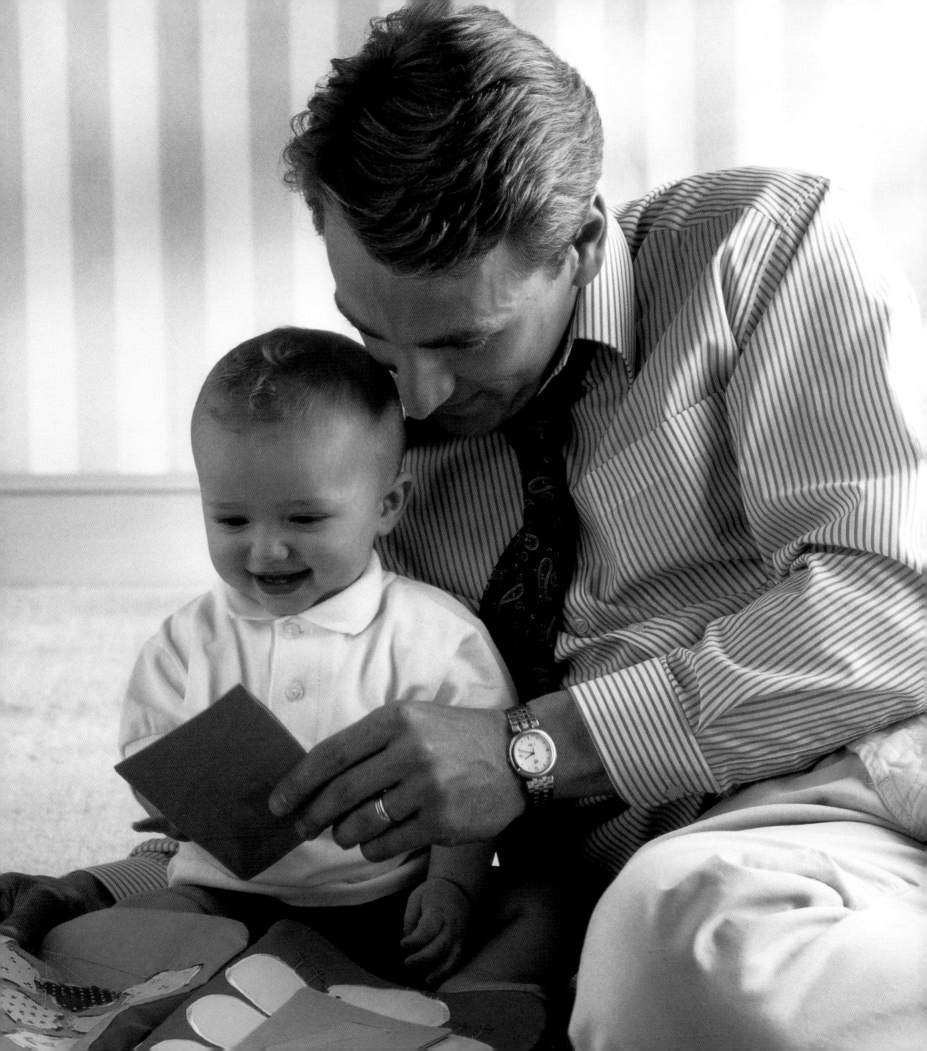

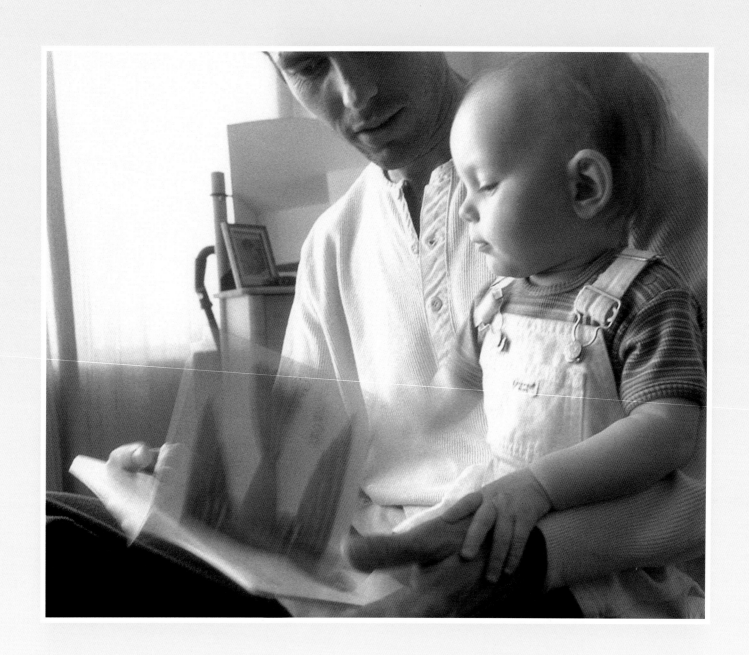

FEATHERING THE NEST

Mama birds certainly aren't the only ones who help to build a nest. The papa birds often are the ones out gathering bits of moss and animal fur, twigs and leaves. And so it is with humans. Rodd remembers pre-fatherhood this way: "I nested—my wife didn't. I made a 'to do and to get' list (which I still have) that included everything from nursery furniture, car seats, and hospital supplies to extra towels for out-of-town visitors and tweezers (I have no idea why this is on the list)."

But not only do parents make space in the home for a new child, they must also make space in their hearts and minds. As Harvey recalls: "As for getting the place ready, my wife mostly did all that. I observed. Eventually, once our son was born, we bought a new house so I was really involved in that, but during her pregnancy, I mostly nested by fantasizing what it would be like to have a child." Explaining that he and his wife had elected not to know the sex of their child, despite having amniocentesis records available to them, Harvey continues: "Finally, I had a dream one night that we were having a boy. Once I had that dream it turned into a gut feeling that we were having a boy, and—I know it sounds stereotypical, but it was true for me—I started to fantasize all the time what it would be like to

Left: Some of the most intimate experiences for both father and child are the times spent exploring the heart of the mythical lands of "once upon a time."

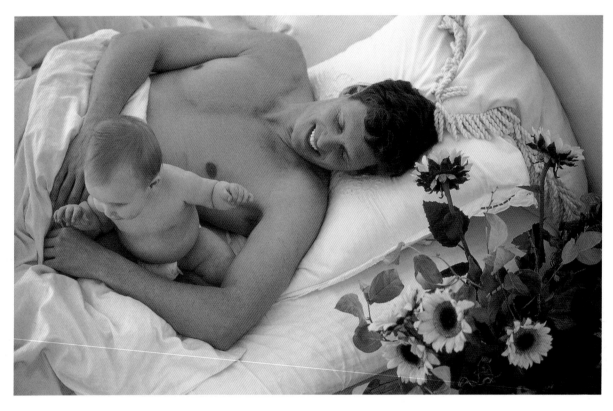

Above: A new baby's curiosity and desire to explore seem endless. Right: A dad is just a child at heart—a sunny picnic with his son inspires any dad to relax and have fun.

go out and throw a ball around with my son, you know, all that guy stuff."

David's particular nesting concern, which he had to put in order before the arrival of his son, was the very notion that he would be having a son and not a daughter, as his wife's amnio results conclusively showed. "My wife had been dreaming that she was going to have a daughter, so I just assumed that we were. I was so excited about the idea of having a little girl that when the amnio tests showed

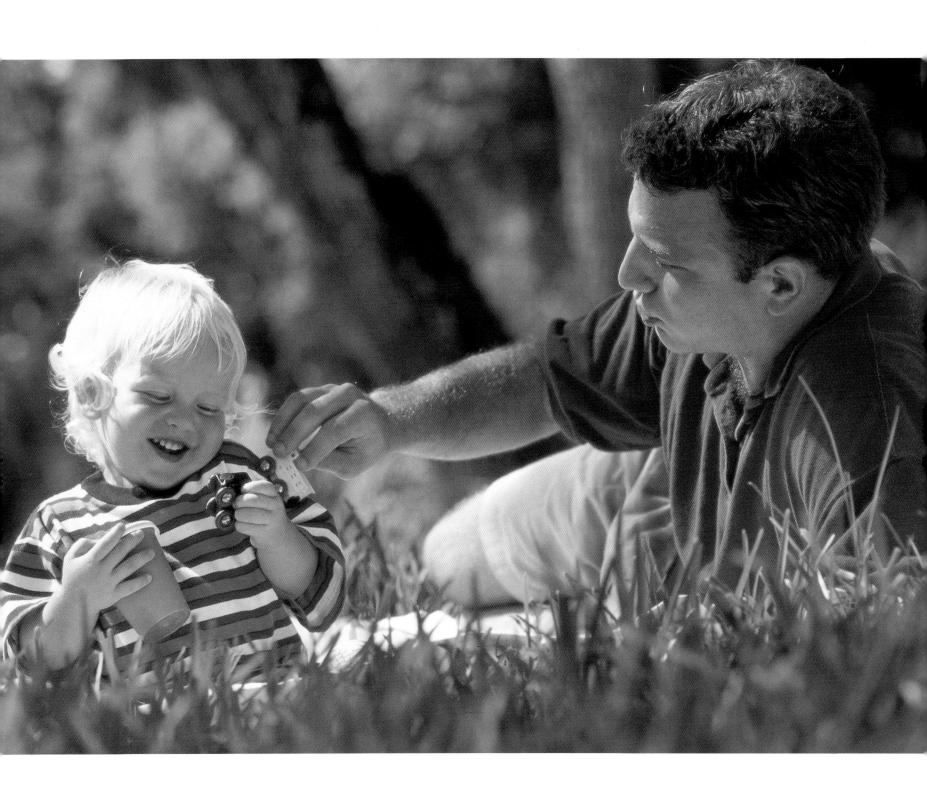

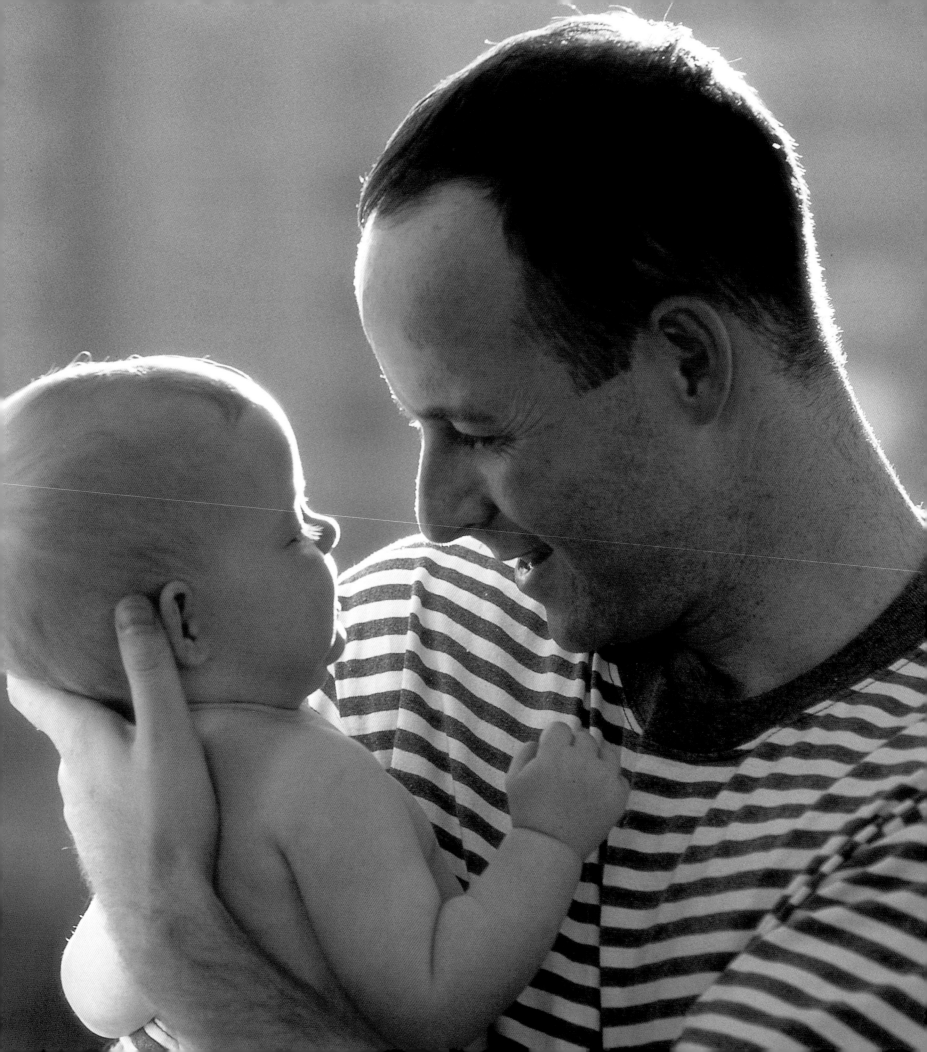

we were going to have a boy, I was devastated. It was almost like I felt betrayed. It wasn't really rational, but I had already begun to open my heart to this little girl—we had her name picked out and everything. I am really glad we had the test, though, because by the time our son was born, I was really into the idea of having a little boy, and, as I guess happens with every parent, you love whichever you get. Now, it seems only right that I have a son. Other than that, I painted our bedroom."

Mark felt a bit more settled emotionally, but found that the sorts of nesting activities he dreamed of were thwarted by local zoning laws. He was unable to complete the sorts of alterations to their home that they had envisioned, including to the nursery, which, despite their son's arrival, Mark says is still "in disarray."

John M. said that his wife's first pregnancy found him feeling a bit anxious to get the consulting business he runs from the remodeled basement of their home up and running at full speed. He was pretty happy with the results, though, noting that the impending birth of his first child helped him to "pretty much" achieve his business goals for that year.

Since Michael and his wife live in a major city and spend weekends in their country home, they have two nests to attend. They spent "a *long* time" renovating the bathroom in their weekend retreat, and not so much

time on their city home, having already invested in it a few years before. They combined two apartments into what is now their three-bedroom, two-story home "with *seven* closets," boasts Michael, who is used to having next to none after years of living in a city notorious for apartments with few or no closets.

Right: A precious daughter is never a burden to bear. Together, this father and daughter stop and take time to grab the roses.

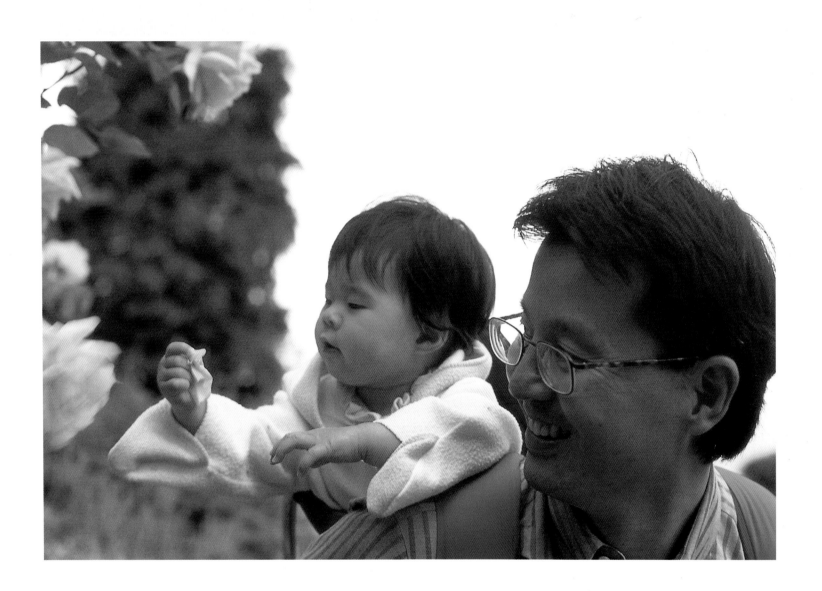

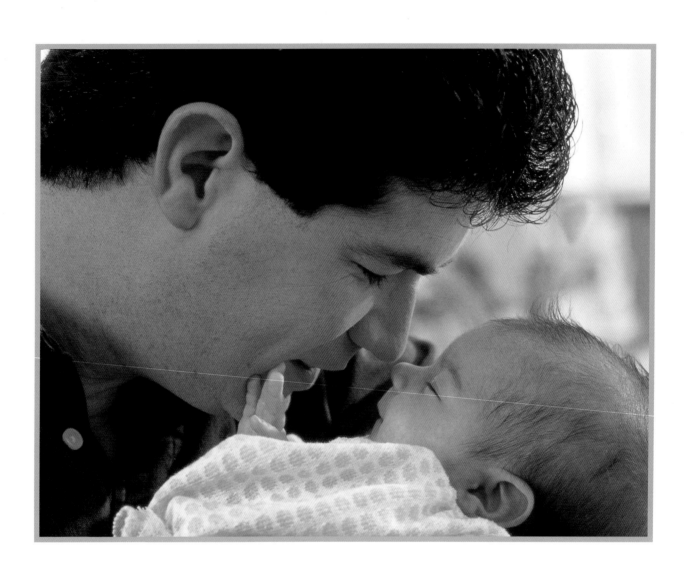

4

D Day
(Delivery Day, That Is)

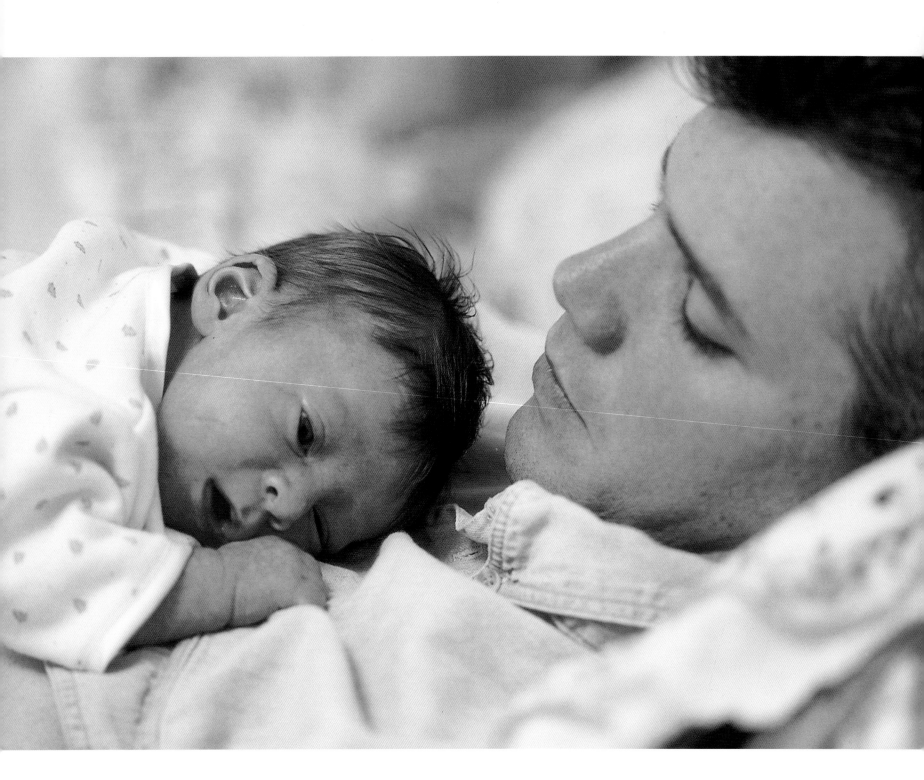

Hollywood is noted for its decidedly chirpy depictions of labor and childbirth. Movies like *Father of the Bride: Part II*, starring Steve Martin, or *Nine Months*, starring Hugh Grant, while entertaining and funny, give the impression that labor and birth are almost entirely giggles and thrills. All that can certainly be part of it, but unlike the movies, where the birth process is represented in a five-minute film sequence, if it even takes that long, real live birth can take hours, and even two or three days. It begins with tiny contractions that gradually swell into waves crashing against both parents' walls of fear and anticipation. And, while it is fair to say that no one ever really knows what to expect, sometimes things go beyond that which parents are prepared for, either emotionally or physically.

In an unusual instance of a husband being more in tune with her body than his wife, John M. actually insisted his wife go to the hospital: despite her arguments to the contrary, he "knew" she was having contractions. As they had discovered the first time around with the birth of their son, John M.'s wife is blessed with easy labors, and on the birthday of their second child, she had barely even noticed she was almost to stage three of her labor by the time he insisted they go to the hospital. "She just kept on saying she had stomach cramps," he remembers. "But I thought she was wrong—I knew it was definitely contractions and when I finally got her to go to the hospital at two in the afternoon, [our daughter] was born only

Left: Flesh of my flesh, bone of my bone. The gift of life can sometimes astound a father, who might hear himself asking, "Are you really a part of me? I helped to create you?"

51

three and a half hours later, at 5:30." Once there, he says, it was pretty straightforward, with no out-of-the-ordinary occurrences. "It was nice because [other than the doctor and the nurse] it was just the two of us and we could really be close and bond," John fondly recalls.

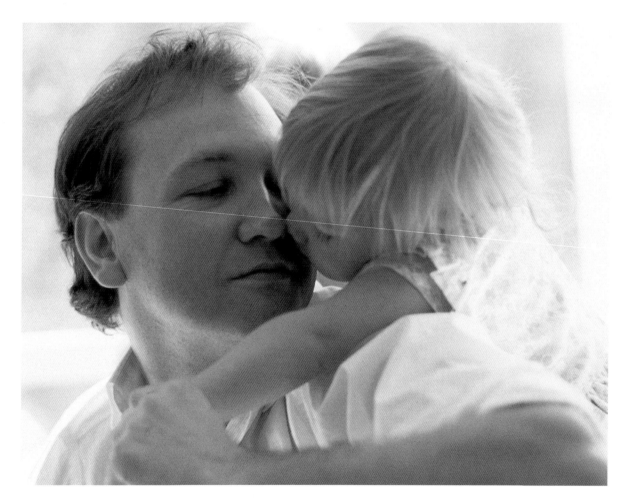

Above: Even as a child grows, a father remembers his or her first moments of life.
Right: A dad reassures his premature infant—and himself—with the
warmth of his hand.

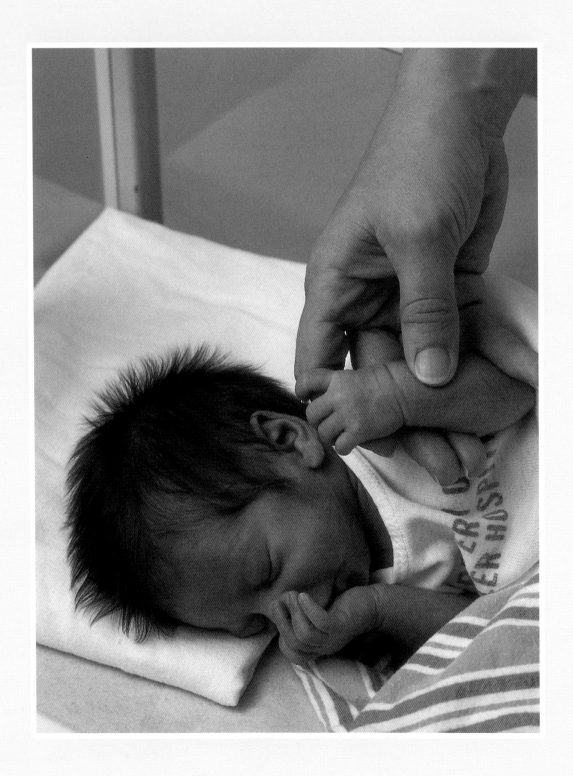

Such cool-headed assurance as John M.'s was not the reaction Mark had to his wife's labor. Their son arrived two weeks earlier than the due date, taking them a little off guard. Mark recalls his wife's self-assurance and serene but powerful demeanor, saying: "[She] was much calmer than I was, at least initially. She was able to instruct me on packing her bag, and for the most part, took care of all the things that we needed to attend to [before leaving for] the hospital. Actually, I couldn't even remember where to go in the hospital, and since it was 2:00 A.M. there weren't many people around [to ask]. But she was totally in control. I also remember her being very no-nonsense in dealing with the hospital personnel. At one point they told her that they didn't have any of the pre-admit papers, and that she would have to fill them out again. But she had hand-delivered them herself to the hospital two or three days prior. She basically told the nurse that she wasn't going to do any paperwork, and that the nurse should leave the room. Whew! I guess they found the papers, as that was the last we heard from that nurse."

Rodd remembers the day with a mixture of horror and his self-proclaimed "tasteless" humor: "Our delivery was at first induced, but after several hours of intense labor, a nurse discovered that the baby was positioned butt-first. This meant an immediate C-section, so all of the anxiety and spontaneity of a vaginal delivery was replaced with a 5:00 P.M. appointment in the operating room. Everything about the birth of our

Right: "I could not point to any need in childhood as strong as that for a father's protection."
—Sigmund Freud

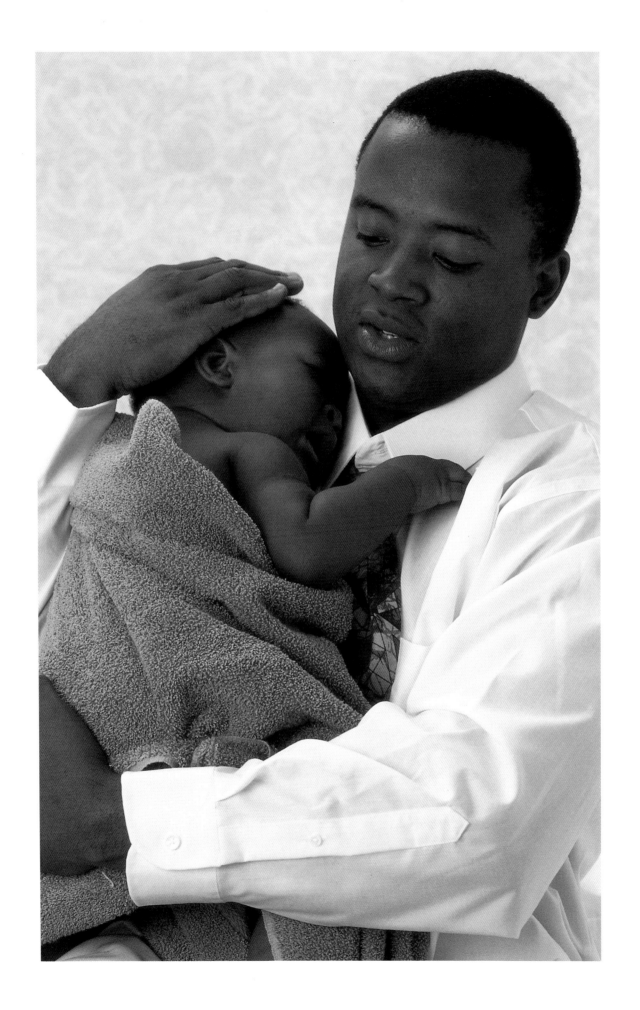

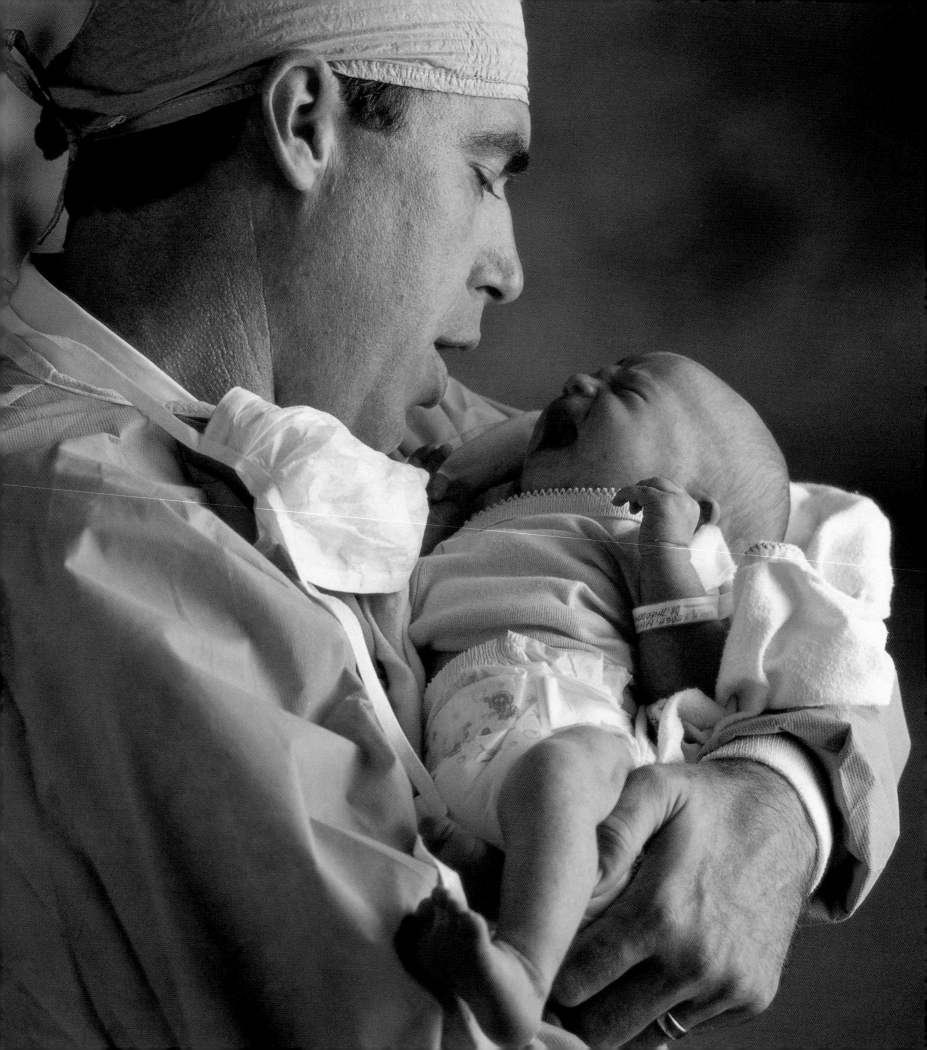

child gets played over and over in my mind many times, but the thing that stands out most was holding my wife's hand while the both of us cracked jokes and I watched unspeakable things happening to her out of her sight."

Michael agrees that C-sections diminish the level of spontaneity and anticipation, more so in his wife's case, since his wife's placenta previa condition required them to schedule a C-section months before: "[Scheduled] C-sections are unusual because there's no transition. You just suddenly have a baby in your arms." Still, in what was vaguely reminiscent of a scene from a movie in which the mom-to-be thinks, "This is it," only to be sent home from the hospital to wait it out, Michael and his wife had a false alarm of sorts. They appeared at the hospital for their scheduled C-section only to have the doctor tell them that her gestational diabetes problem seemed to be under control and the baby was not particularly heavy, so if they didn't mind, perhaps they should wait another week. They did, but that meant Michael's in-laws, who had driven several hours to be there at the appointed hour of birth, spent the night only to drive home the next morning and return again the following week. When their son finally was delivered, Michael recalls that the newborn did not cry, "he yelled. He definitely yelled." The doctor handed Michael his son and with his newborn in his arms, he trotted around his wife's gurney singing an old horse-trot song, "Chickory Chick," before placing the babe on his wife's chest. He had to help hold the baby there, since the

Left: "Welcome to the world! I'm your daddy and we're going to be together for a long, long time."

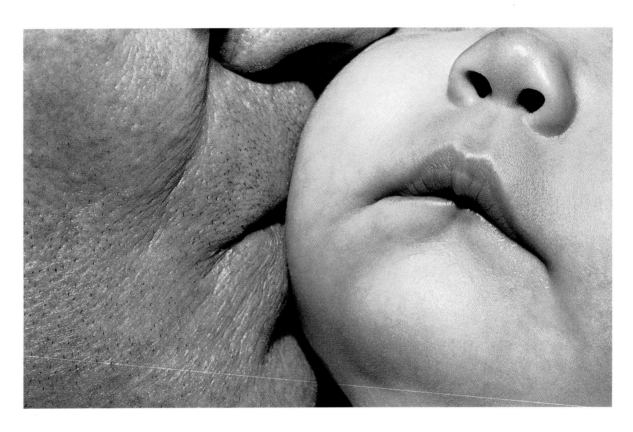

Above: "I am furrowed and you are smooth, but your arrival has made me fresh and new."
Right: Catching his busy toddler by surprise, a daddy steals a kiss from his tot.

anesthesia had caused some complications in her arms, but they were exultant nevertheless and Michael praised the hospital staff, especially the nurse with whom they had taken childbirth education classes during the pregnancy.

While Harvey and his wife were impressed by their doctor's abilities, they ultimately did not feel so cozy toward the staff of the hospital during the birth of their child. Harvey says that, unfortunately, the rough treatment they were handed stands out in his mind and makes him feel a bit

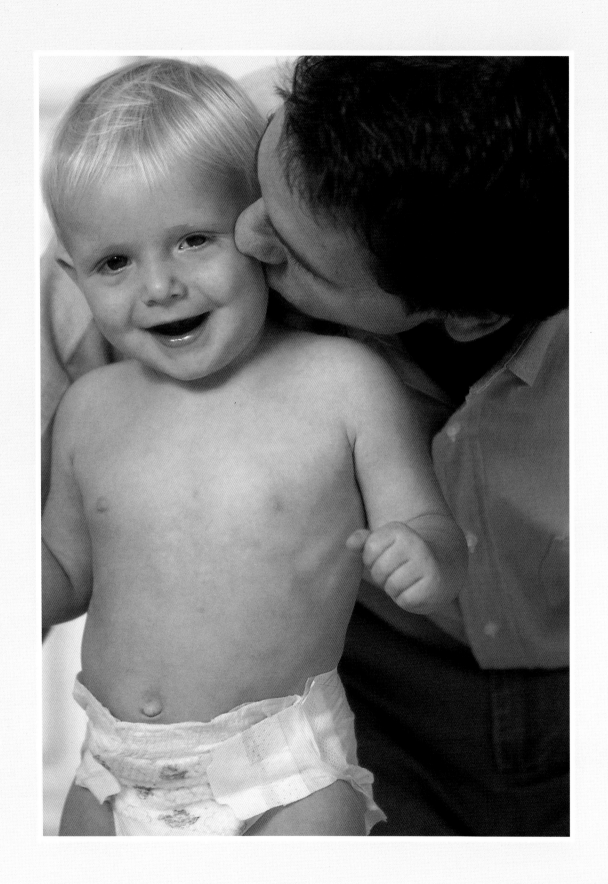

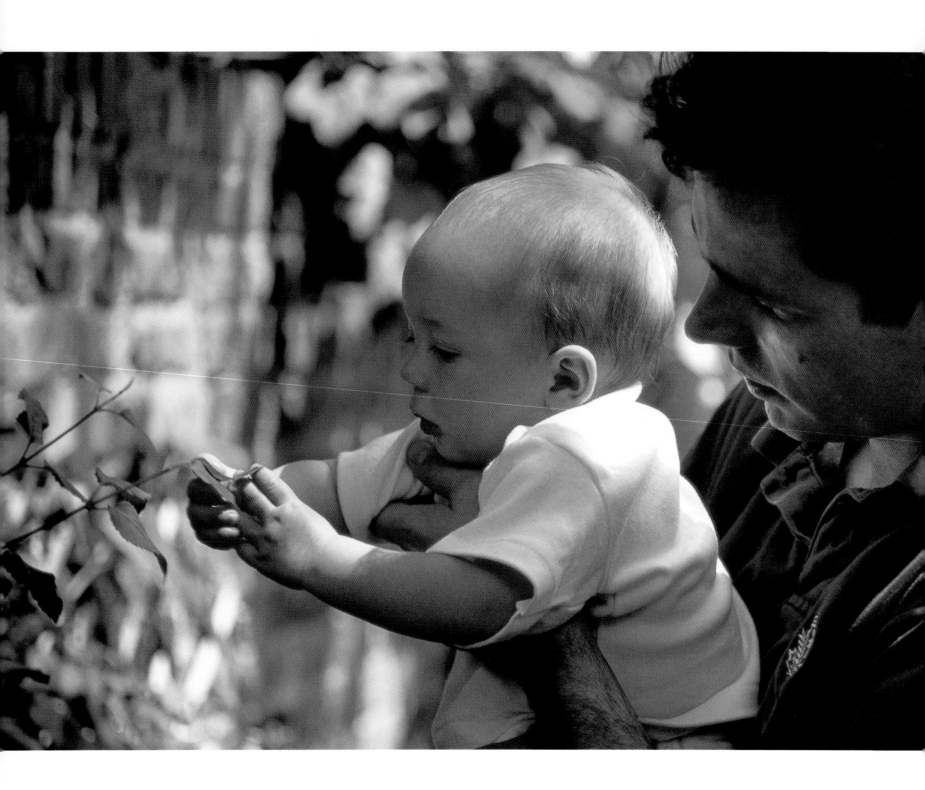

sad when he remembers what should have been an all-around joyful event. It wasn't until approximately 11:30 P.M. that the doctor told Harvey and his wife that they should head for the hospital. But, by then, Harvey's wife had been laboring since 5:30 A.M. and her pain was growing steadily.

By the time they arrived at the hospital, the doctor told them that, because she was five centimeters dilated, Harvey's wife would be pushing the baby out shortly. "I was really excited about that but then they discovered that the umbilical cord was wrapped around his neck and the next thing I knew I was scrubbing up for surgery." The anticipation Harvey felt turned immediately into anxiety, resulting in severe muscle spasms that nearly knocked him over. Plus, what had started out as just the two of them quickly became a crowd as interns and residents filed in to observe the doctor and nurses deliver a baby under less-than-ideal circumstances. The doctor decided upon forceps delivery, which Harvey says "went smoothly," but was anticlimactic and not as "thrilling" as it was traumatic.

Unfortunately, Harvey's and his wife's trials didn't end there. In a decision Harvey says was not really made with his and his wife's input, the staff who had helped deliver the baby determined that the child had hypoglycemia and, without waiting for the parents to become much acquainted with him, whisked the child off to the intensive care unit. "They never really told us what the exact complications or dangers of low blood sugar [in a newborn] were. What ended up

Left: It's a daddy's job to point out the details. 61

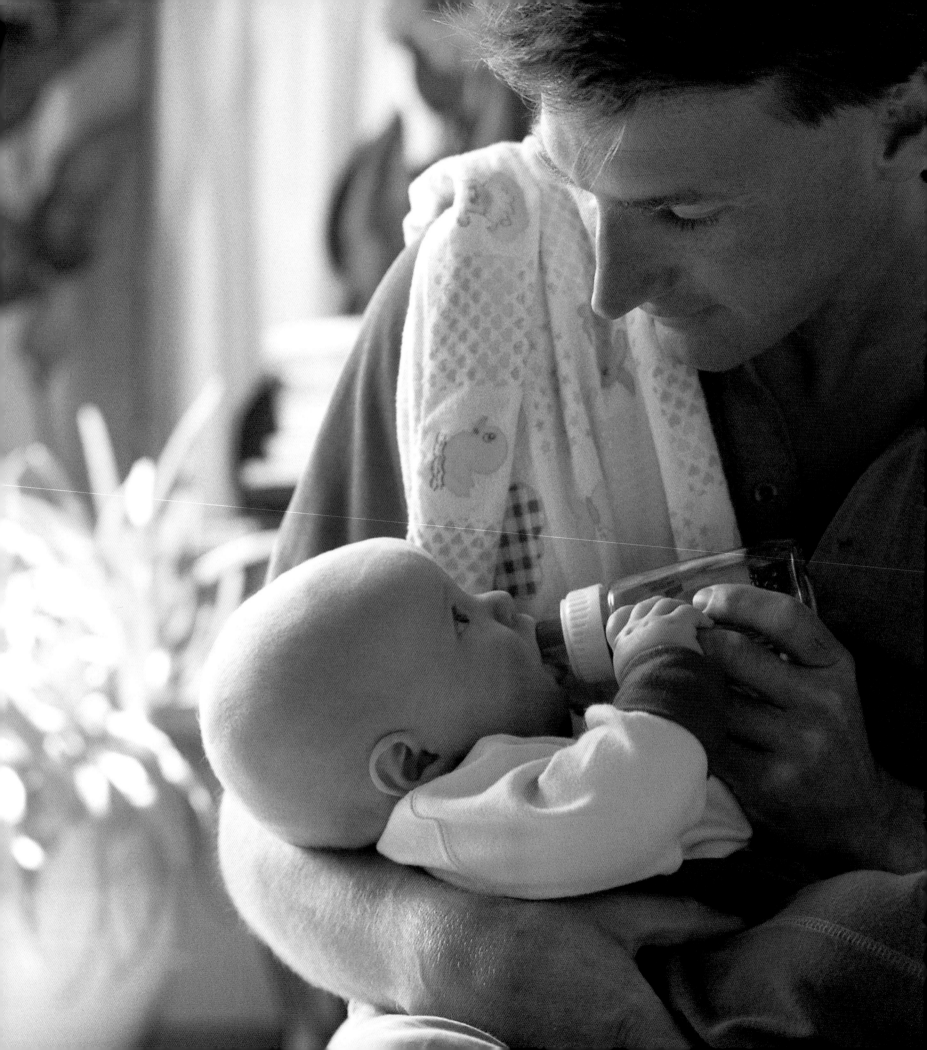

happening is that it totally interfered with the breast-feeding schedule and really stressed us and the baby out."

Despite a bit of anxiety when his wife had to have an emergency C-section during the birth of their first child, John Z. remembers the day with levity. His wife had gone into labor during the middle of an intensely rainy, early-autumn nor'easter, the likes of which hadn't been seen for decades. By the time their son had been delivered, John Z. was spent from the stress and from not having slept in more than twenty-four hours. When he exited the hospital, the storm was so fierce that in his bleary-eyed state he became greatly disoriented and completely lost track of where he had parked the car. In the blinding wind and rain, he searched the street he thought he'd parked on the evening before, but to no avail. Fearing that he had misunderstood the parking rules for that neighborhood and that his car had been towed, he went to the police, who, according to John Z., weren't much help. Finally, sheer exhaustion forced him take public transportation home. When he woke up several hours later, he clearly remembered the exact spot he'd parked. When he returned, his car had not been towed, "but," he laughs, "I got a nice ticket!"

David emphasizes that had he and his wife not hired a doula (a birthing coach), he does not think he would have made it through. "She was like an angel sent from heaven," he says of the doula. "My wife's water had broken at 7:30 that morning, but by the time her doctor felt

Left: There's a whole world to see and explore, but it'll have to wait, as a dad bonds with his daughter through the intimacy of a quiet bottle feeding.

that she was dilated enough to come to the birthing center, we had taken four taxi rides between our home, the doula's, and the doctor's office. I think the last guy who actually drove us to the hospital thought he would appear on the evening news, since by then my wife was just on the verge

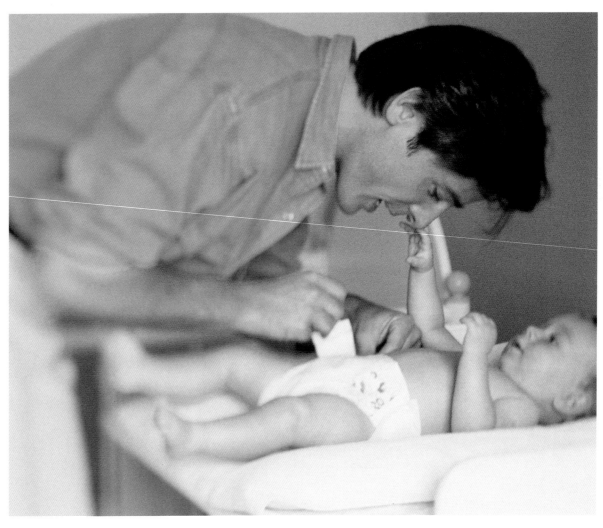

Above: "Yes. That's daddy's nose." Right: A hand to hold, a shoulder to lean on. A dad's love is solid as a rock.

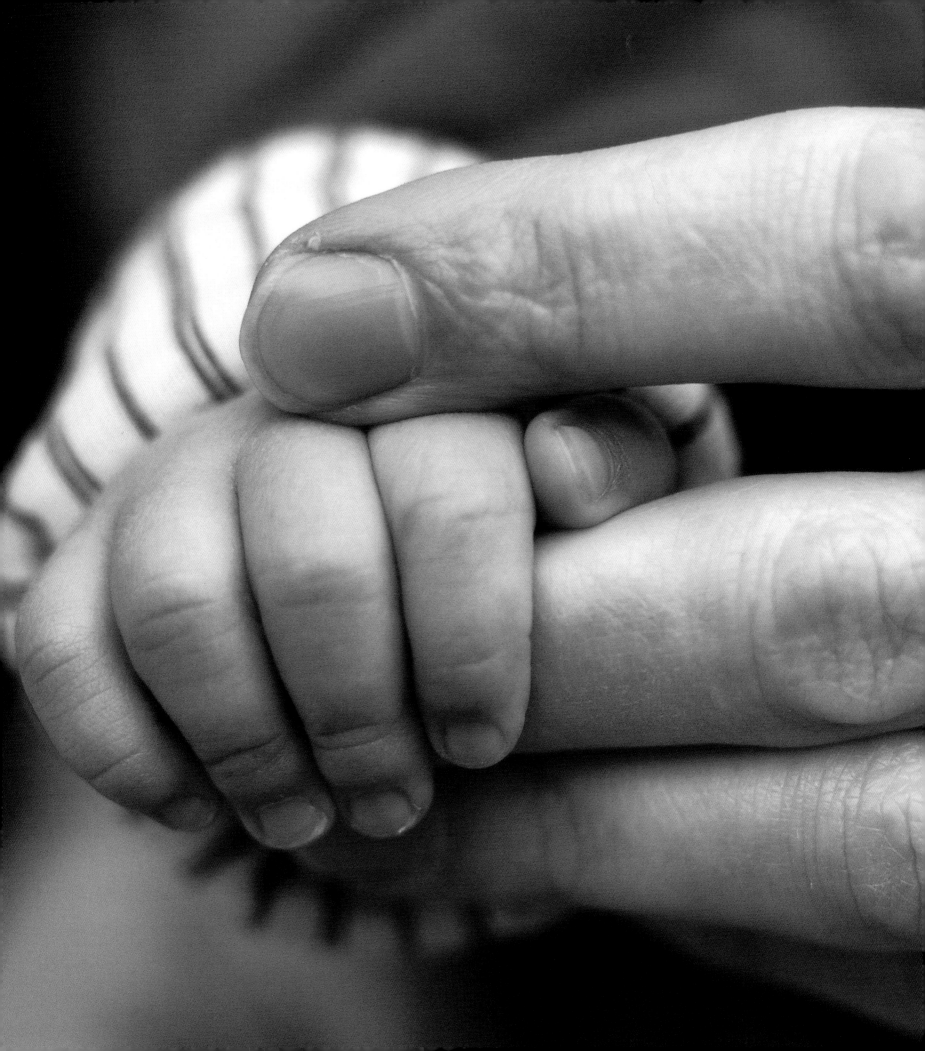

of starting to push. She'd gone from not being dilated enough to suddenly being nine centimeters, all in about two and a half hours. The driver spent twenty percent of his time watching rush-hour traffic and eighty percent of his time smiling at me in the backseat and saying, 'I have nine children.' Meanwhile, our doula gave the bizarre suggestion to the driver that he put his flashers on so that people would know he had a pregnant woman in the cab, and that then he should run all the red lights. Thankfully, he ignored her.

"My wife was already in the transition phase by the time we had helped her into the car. She could barely speak but when she did, it was to say she felt like the pain was going to kill her. I was so nervous and scared. Eventually, when we had her all settled in the birthing room and she had made it out of transition and into the pushing phase, I couldn't sit still. By then, she had regained her composure and insisted that the room stay quiet. I was pacing back and forth until, from where she lay draped over her 'birthing ball' (it's like a huge sturdy beach ball), she said between contractions, 'Honey, sit down. You're making me nervous.' She told me she was okay, so I relaxed.

"I held my wife's hand when it came to the final moments. Until then, she had been squatting by herself on the bed and hadn't wanted anyone to touch her. It was indescribably thrilling when my son's head crowned. It was so amazing to watch! I was glad we had taken childbirth education

Right: A serious moment between father and daughter. The look in a child's eyes sometimes can startle a dad with the knowing light he sees in them.

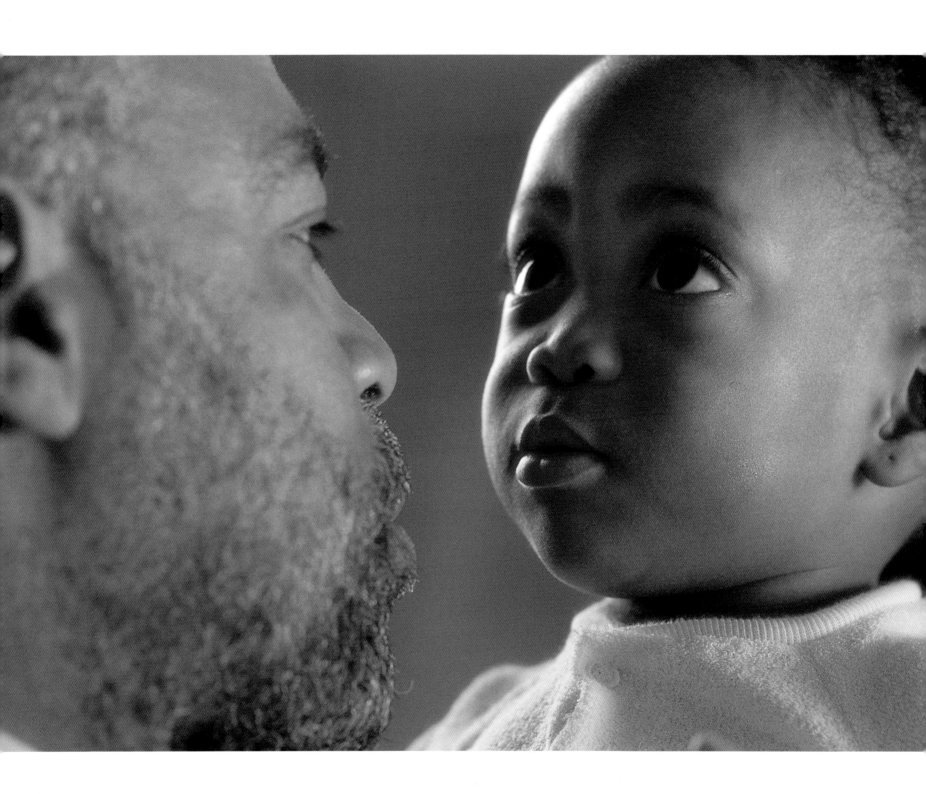

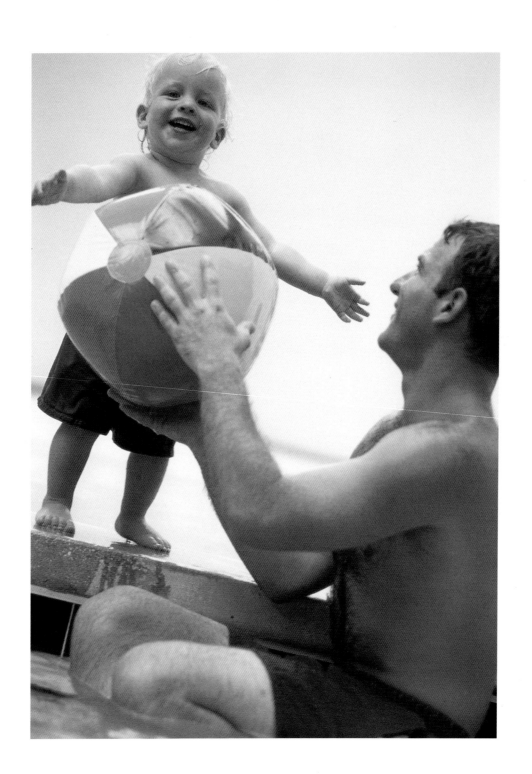

classes so that while it was all happening I knew pretty much what to expect instead of being grossed out or frightened.

"My wife really only pushed for two hours before he was born. I let the doctor cut the umbilical cord, but I was the first to really hold him before giving him to my wife, who sang to him and breast-fed him right away. I went to get my in-laws from the waiting room and told them: 'The good news is everyone is fine,' I said. 'The bad news is he looks like me.' Kind of dopey, but it was all I could think to say, I was so euphoric."

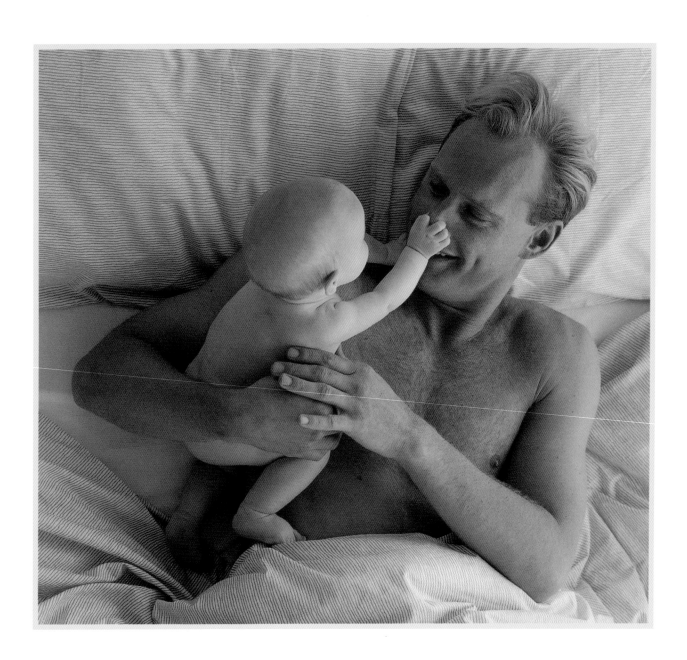

5

EVERYTHING IS DIFFERENT NOW

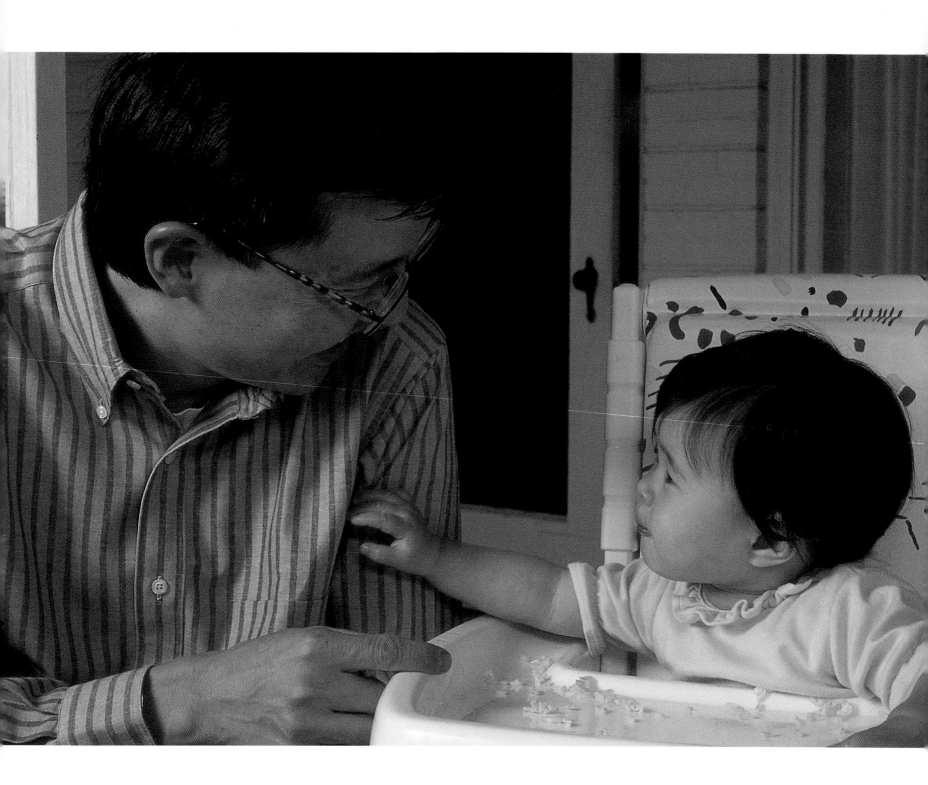

Dad, you are our king—tall and strong and wise and full of laughter. Never dismiss your life as commonplace.

—PAM BROWN, 1928

Babies remake a man's life. As Hugh O'Neill muses, a "dad has to instantly absorb info on car seats, croup, origami, and oatmeal. Stuff a man without kids simply does not have to master. Dad has to know how to get a tiny stretchy sock on a humid kid foot, how to get a giant frayed shoelace though a teensy little shoelace hole, and how to repair a doll's earring."

Rodd welcomes these new duties and the trade-offs they entail: "Some things I used to enjoy have been lost forever: going out to see a movie, relaxing after a day's work. But the obvious fact is that many more things have come into my life that give me a great deal of pleasure. At least once a day, my son does something (not much) that makes my heart melt. Whether that's good for my health in the long term, I don't know, but I know it wasn't happening with that kind of regularity before he came along."

All the daddies in this book agreed: becoming a father changes your priorities forever. John Z. puts it this way: "I have given up a lot professionally, but I believe what I heard once: 'No matter your successes in life, they don't mean anything if you didn't raise your kids right.' I mean, it's not like we are all going to find the cure for cancer. The best thing we can give the world is well-raised children."

Left: "No, Daddy! That's my rice. Get your own!"

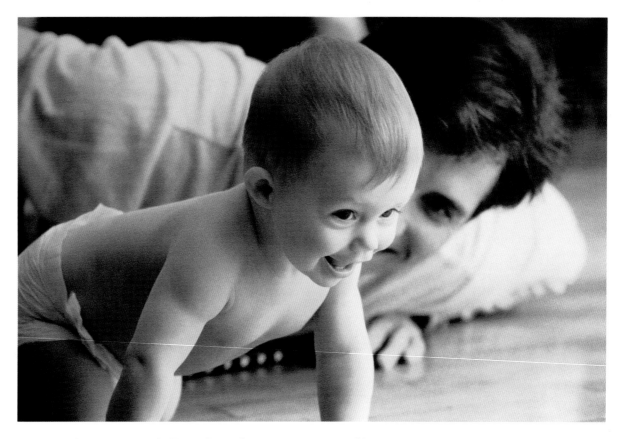

Above: As his child's independence continues to blossom, this daddy will continue to try to keep up. Right: "A little child, a limber elf, singing, dancing to itself, makes such a vision to the sight as fills a father's eyes with light."
—Samuel Taylor Coleridge

John M. says that, actually, "becoming a father has been a lot more fun than I ever would have expected. But it requires a lot of work, too. You just have to narrow your focus sometimes." John M. adds that it also helps that once you're a father, "you become more selfless." Harvey puts it this way: "I think a lot about [my son's] self-esteem, how to nurture it."

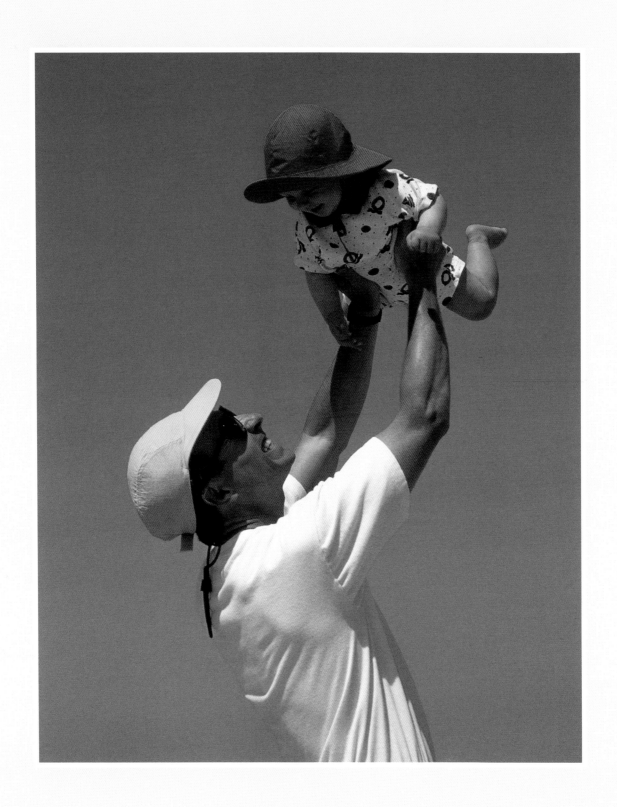

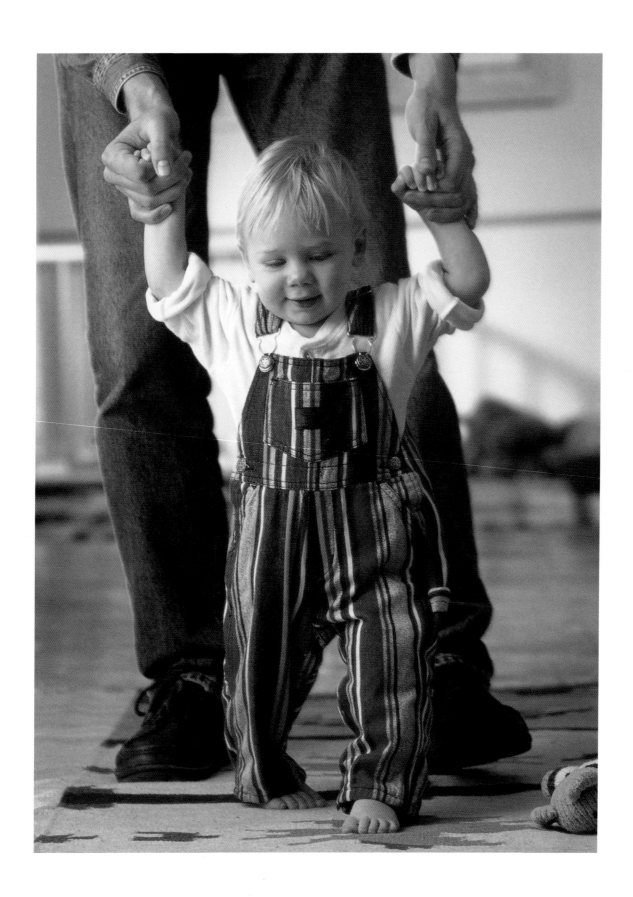

The more practical things crowd a daddy's mind, too: Harvey laments that if nothing else in his life has changed, he now needs "more planning!" Sighs Harvey, "You've got to pack everything and plan it out. It's all about planning and having an awareness of time itself. We just moved, for example. And because my son demands attention, the unpacking took three times longer than it would have otherwise. You know, you just change your expectations of what you want to do and what you can actually get accomplished."

Mark agrees: "I was always the cook before, but now it has to be a little more regular, as my wife needs to eat a little more often since she's breast-feeding. I'm a little overwhelmed at this point about getting things done . . . the singing, the consulting business, the household duties. But I'm sure it's just a matter of getting into a routine." Mark also relates how, as a dad, he finds himself more aware of the way bringing his baby along affects others when they are in public: "When we went out to dinner for the first time [after he was born], I really [saw] things in a different light. I worried about the baby crying (he didn't), and how the restaurant personnel would treat us (they were nice). It was quite different. We also had to choose the restaurant more carefully, obviously."

The journey *to* fatherhood is over. But the journey *through* fatherhood is just beginning. The labor and delivery is a memory, however recent or distant, and the man, the husband, is now a father. Having a string of nights of entirely uninterrupted sleep is considered a triumph. And with

Left: For a tot, walking brings on a whole new perspective. A dad knows the thrill and anxiety such newfound freedom brings to his child.

every passing day it becomes more and more difficult to remember life before being a father. A man wonders, "How did I used to feel about that? Did I really think and say those things? Where did I ever find the time to do that?" Everything is different now. The initiation is over and the mysteries begin to unfold. Through it all, a man—a father—finds that he need only to hear his child call out, "Daddy," to find that his heart has melted and he is glad for it. A father need only hold his child's tiny hand to be consumed with a fiery desire to forever protect such an innocent beauty as the son or daughter he loves. Says David of his son: "He has catapulted me into being responsible in ways I have never before been in my life. I love him so much and it makes me feel vulnerable in ways I have never felt before. I think it's because I love him so much that the thought of ever losing him is beyond painful. I am more aware of everything I do in my life now, how it all affects him." Michael echoes the sentiment, saying incredulously, "I don't understand how there can be so much evil in the world brought about by people who've had children."

Right: "There's a whole world waiting for you to define it! I see a fiery dragon and an angelfish floating by . . . what do you see?"

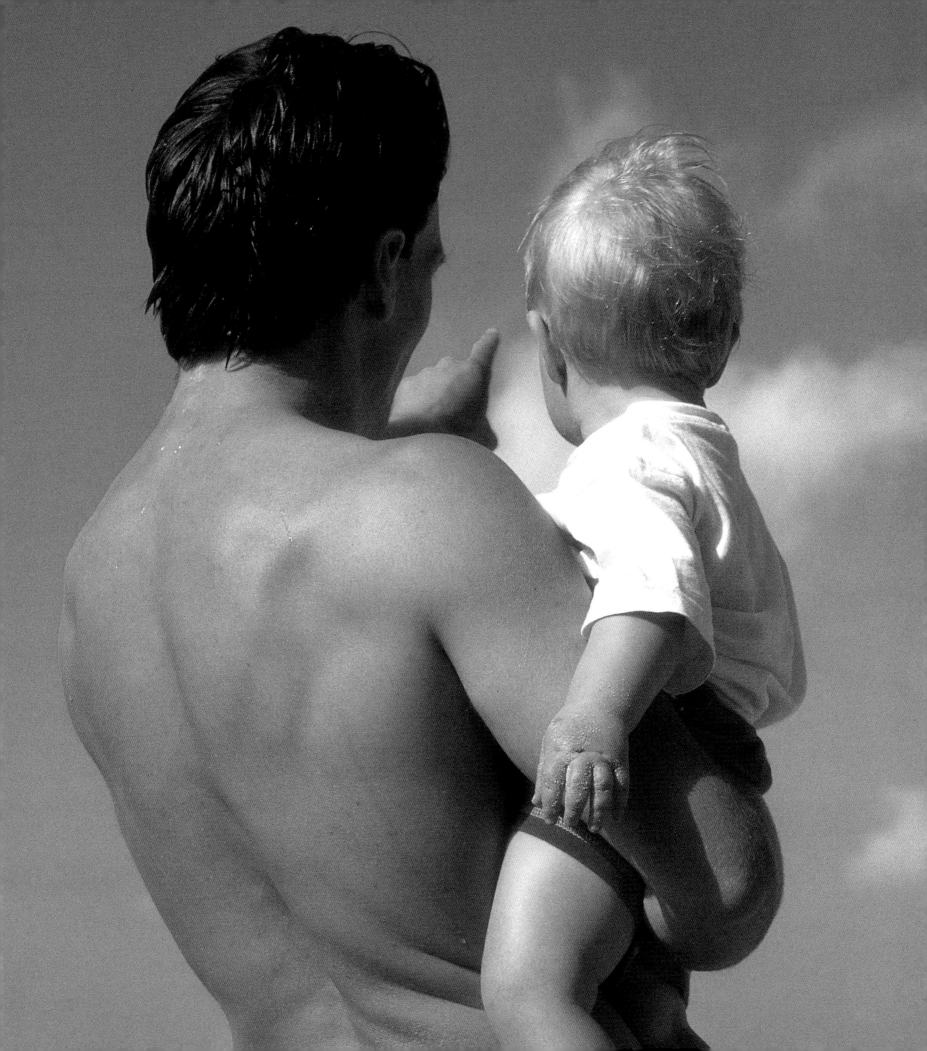

Credits

FPG International: ©100% Rag Productions: 40; ©AdamSmith: 59; ©Gary Buss: 22; ©Ron Chapple: 5, 75; ©Dick Luria: 18; ©Court Mast: 16; ©James McLoughlin: 24; ©Jeffry Myers: 47, 72; ©Navaswan: ii, 21; ©Barbara Peacock: 32, 50; ©C.J. Pickerell: 53; ©Stephanie Rausser: 14, 27; ©Mark Scott: 30; ©Stephen Simpson: 44; ©Telegraph Colour Library: 25, 36; ©Arthur Tilley: 34, 43, 55, 68

Tony Stone Images: ©Elie Bernager: 64; ©Christopher Bissell: 35; ©Jo Browne/Mick Smee: 60; ©Gus Butera: 12; ©Andy Cox: 39, 70; ©Laurence Dutton: 76; ©Paul Edmondson: 7; ©Roy Gumpel: 11; ©David Hanover: 8, 20, 74; ©Robert Holmgren: 58; ©Dennis O'Clair: 48; ©Vincent Oliver: 28; ©Rosanne Olson: 83; ©Philip & Karen Smith: 62, 79; ©Paul Stover: 2; ©Charles Thatcher: 67; ©Terry Vine: 56; ©Caroline Wood: xii, 42

Leo de Wys: ©Charles Bowman: 65; ©de Wys/SIPA/Brandt: 52